A
MAN
&
HIS
WATCH

ALSO BY MATT HRANEK

A Man & His Car

A MAN & HIS WATCH

ICONIC WATCHES & STORIES
FROM THE MEN WHO WORE THEM

MATT HRANEK

PHOTOGRAPHS BY STEPHEN LEWIS

ARTISAN | NEW YORK

Library of Congress Cataloging-in-Publication Data

Names: Hranek, Matt, author.
Title: A man and his watch / Matt Hranek.
Description: New York : Artisan Books, 2017. | Includes bibliographical references and index.
Identifiers: LCCN 2017004928 | ISBN 9781579657147 (paper-over-board : alk. paper)
Subjects: LCSH: Men's wrist watches—Anecdotes.
Classification: LCC NK7484 .H73 2017 | DDC 681.1/14—dc23
LC record available at https://lccn.loc.gov/2017004928

Cover and slipcase photographs by Stephen Lewis

Design by Renata Di Biase

Artisan books are available at special discounts when purchased in bulk for premiums and
sales promotions as well as for fund-raising or educational use. Special editions or book
excerpts also can be created to specification. For details, contact the Special Sales Director
at the address below, or send an e-mail to specialmarkets@workman.com.

For speaking engagements, contact speakersbureau@workman.com.

Published by Artisan
A division of Workman Publishing Co., Inc.
225 Varick Street
New York, NY 10014-4381
artisanbooks.com

Artisan is a registered trademark of Workman Publishing Co., Inc.

Published simultaneously in Canada by Thomas Allen & Son, Limited

Printed in China on responsibly sourced paper

12 13 14 15 16 17 18 19 20

For my father

CONTENTS

PREFACE

I have my father's watch. It's a Rolex Oyster Perpetual Datejust, stainless steel with a black dial. I remember the day my father came home with it on his wrist. He was so proud, and I was so happy for him, because I knew the watch was more than just a new timepiece; that Rolex marked his first successful year in business for himself.

When I was a kid, my father was always pointing out to me well-designed and well-crafted things: cars, motorcycles, architecture, and, of course, watches. When he died suddenly—I was only eighteen—I was given his watch. Or maybe I just took it.

All I knew was that I *needed* to have that watch. I needed him with me—and that watch kept me connected to him. It still does every time I wear it, every time I look down at it. I now own other, more valuable watches, ones that are more impressive to collectors, but nothing can replace that Datejust. It remains such a powerful representation of my father. I couldn't bear not having it in my life.

For many men, watches seem to have a deeper meaning than just keeping time. Watches mark special occasions, they tell the world a bit about who you are, and they can, if you're lucky, connect you to the people in your life who matter most.

I was always a "watch guy," but it wasn't until my recent role covering the watch market as a magazine editor that I started unearthing these amazing stories—historical anecdotes from the major watch brands, or more personal ones from friends, colleagues, and collectors with whom I began to cross paths in the watch world. There's a powerful thread uniting these stories and these men—whether they're alive or dead, wealthy and famous or clock-punching everyday guys. Watches are objects that start conversations among men who notice them. I began to realize that the watches worn on the wrists of the men I knew often had great emotional significance, or

"Watches tell the world a bit about who you are, and they can, if you're lucky, connect you to the people in your life who matter most."

—MATT HRANEK

represented some deep connection—the watch had been given to them by a relative, it marked a major life event, or maybe it allowed them to be the version of themselves they most wanted to be. This book tells some of those stories.

The book had to start with photographing one of the most iconic timepieces ever, the Rolex Daytona that Paul Newman owned. This model, for many, is *the* watch—an absurdly expensive collector's item that grown men literally spend years hunting for. It is the grail watch for many watch lovers.

The Rolex was a gift from Joanne Woodward, Newman's wife. It was a replacement for the first Daytona that Woodward gave him, a reference 6239, which Newman had given away to their oldest daughter Nell's boyfriend in 1984.

When I finally held this watch in my hands—Paul Newman's actual watch—the feeling was (and I know this sounds crazy) electrifying. But what struck me most was the inscription on the back: "Drive slowly—Joanne." Reading that gave me chills. Thinking about it still does.

Paul Newman was a legend—handsome, talented, stylish, generous; a Le Mans-winning race car driver and a Hollywood icon. But he was also just a guy, a husband and a father, who wore a watch to keep the time. Just like the rest of us. His youngest daughter Clea, who was kind enough to allow us to photograph it, wears it daily; that most famous timepiece, which could fetch millions at auction, is on her wrist while she rides horses and gardens. At the end of the day, a watch is just a watch—it's the story behind it that can make it exceptional.

With that in mind, I started this journey. The more I talked about the book, and my approach to describing the emotional connections that we, as men, have with watches, the more incredible stories I found. I've spent countless months compiling those stories, from all around the globe, and the one thing I've learned is that I've barely scratched the surface.

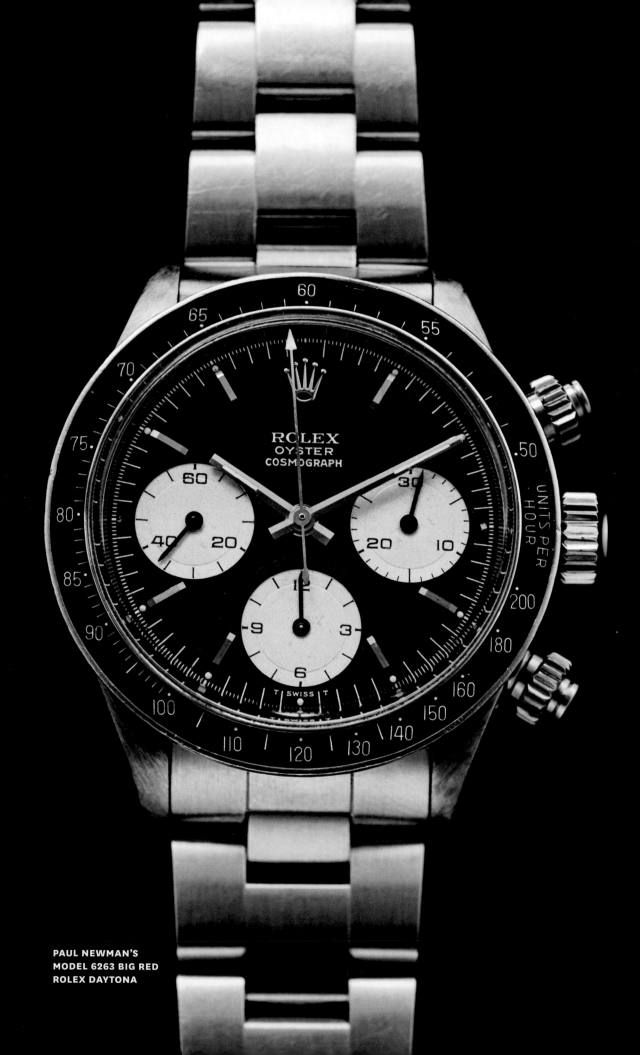

PAUL NEWMAN'S
MODEL 6263 BIG RED
ROLEX DAYTONA

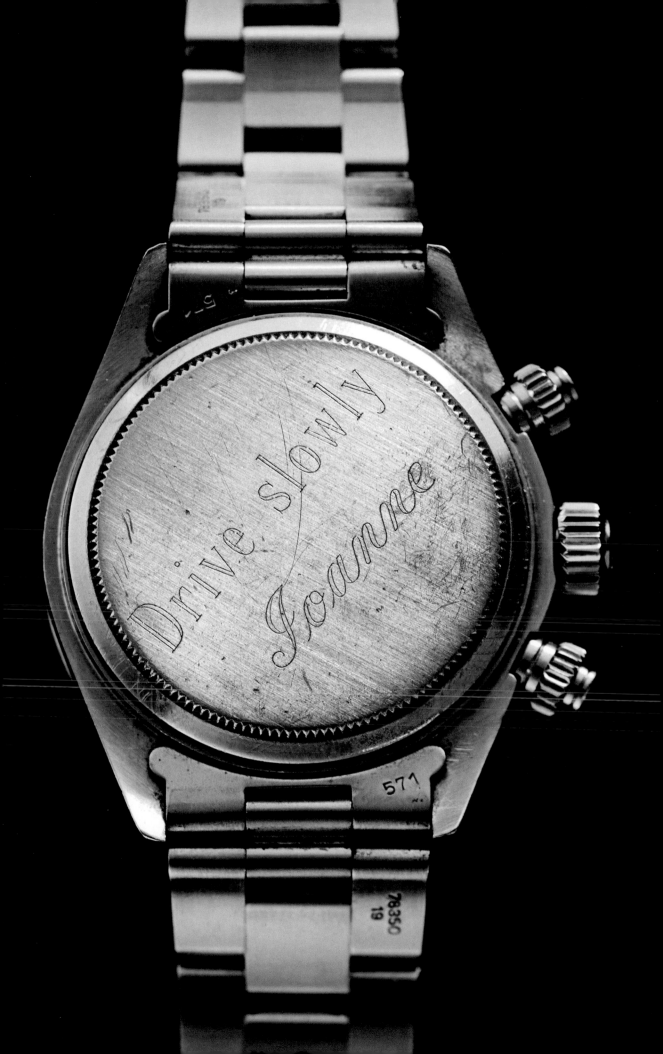

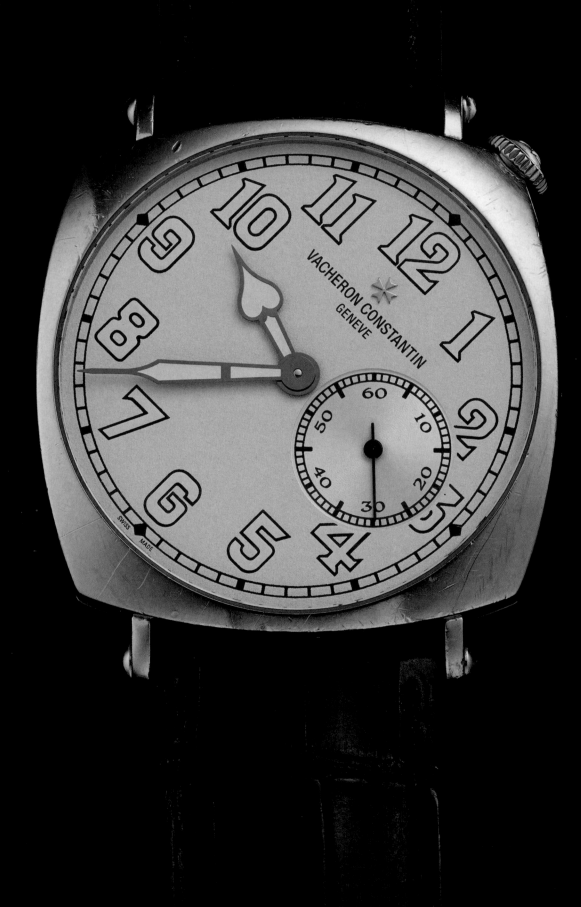

ERIC RIPERT

CHEF & CO-OWNER, LE BERNARDIN

VACHERON CONSTANTIN
HISTORIQUES AMERICAN 1921

When you look down at the time on this Vacheron, you realize that it isn't your average watch. It was originally designed as a driver's watch; in 1921, when cars had those big steering wheels, it was hard to see the time straight-on when you were driving, so the numbers were offset to the right. I like that anomaly.

For me, watches signify special occasions. I'll buy one for myself as a gift, maybe for the holidays—or maybe before, if I can't wait! This watch, though, I didn't buy.

One day, Maguy Le Coze, my business partner at Le Bernardin, says, "I need to meet with you tonight—let's have dinner outside the restaurant." I'm anticipating something serious, but at dinner she's very jovial, very happy. And at the end of the dinner she says, "Now we're going to talk." I think: "Ah, finally!" She puts a box on the table, and in the box was the same Vacheron Constantin American '21 that I had been planning to buy for myself! That was in 2011, which was my twentieth anniversary at Le Bernardin.

Maguy says, "You're the driver—you drive the kitchen, you're our leader. You deserve this watch."

So two things come to mind when I wear it: I remember the day I walked into Le Bernardin, tense, not really knowing what would happen; and I also think of my dear friend and business partner recognizing the work I have done.

Vacheron is a beautiful brand. In the collectors' world you have the classics, like Rolex and Cartier. But when you talk about complex watches, brands like Vacheron, Patek Philippe, and Breguet are very special. It's about the craftsmanship and, in a sense, the artistry.

Cooking, too, is craftsmanship. Take making a sauce: you can't measure an ounce of flavor—it doesn't exist that way. It's intangible; you can't dissect it. Like time. So it's the same with watches: it's

craftsmanship until you reach a certain level of complexity. Then it's artistry. Watchmakers are craftsmen thinking, "How can I get to a solution with a system different from the other guy's?" I mean, the guy who invented the tourbillon had to be pretty twisted! Thinking about how when you cross the equator and then come back, the pressure is different, and creating a solution for that—can you imagine? Most people don't consider this sort of thing, but collectors do. They understand the amount of work that went into that solution.

Some people get mad at me when they see me banging up an expensive watch while working in the kitchen. But I can always send it back to be fixed and repolished. I have the watch to use the watch!

"For me, watches signify special occasions. I'll buy one for myself as a gift, maybe for the holidays—or maybe before, if I can't wait!"

—ERIC RIPERT

FROM THE
ROLEX ARCHIVES

I had seen a magazine piece that Rolex produced about Francis Chichester, a famous twentieth-century adventurer, sailor, and navigator, and this incredible Rolex Oyster Perpetual that he wore on his circumnavigation of the globe. When Chichester left Plymouth, England, in his yawl *Gipsy Moth IV* on August 27, 1966, the Rolex was strapped to his wrist. And when he returned on May 28, 1967, after 226 days of sailing with just a single stop in Sydney, Australia, the very same watch was with him, functioning perfectly, a concrete testament to the unique skill of the Rolex artists and craftsmen in Geneva, Switzerland. I knew this watch was in their archives, but Rolex is notoriously guarded and private about giving people access, so it came as no surprise that I was initially denied entry. But I persisted and said, "You know, a photograph of the watch has already been published, so why not give me permission to include it in the book?" It was a very American thing to do, to keep poking and poking, but eventually, they agreed. Getting into the archives required about the level of security I assume you need to get into the inner sanctums of the White House. But once I was in, it was a powerful, unforgettable experience. And also a bit nerve-racking— but the archivists were the most generous, helpful, and genuinely kind people you could hope to meet, and they made me feel more than welcome.

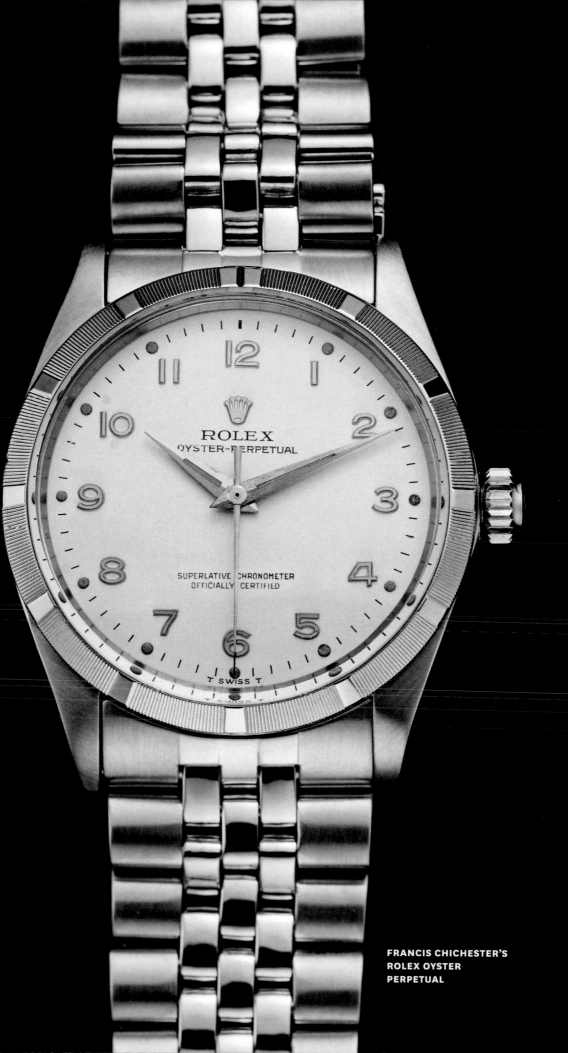

**FRANCIS CHICHESTER'S
ROLEX OYSTER
PERPETUAL**

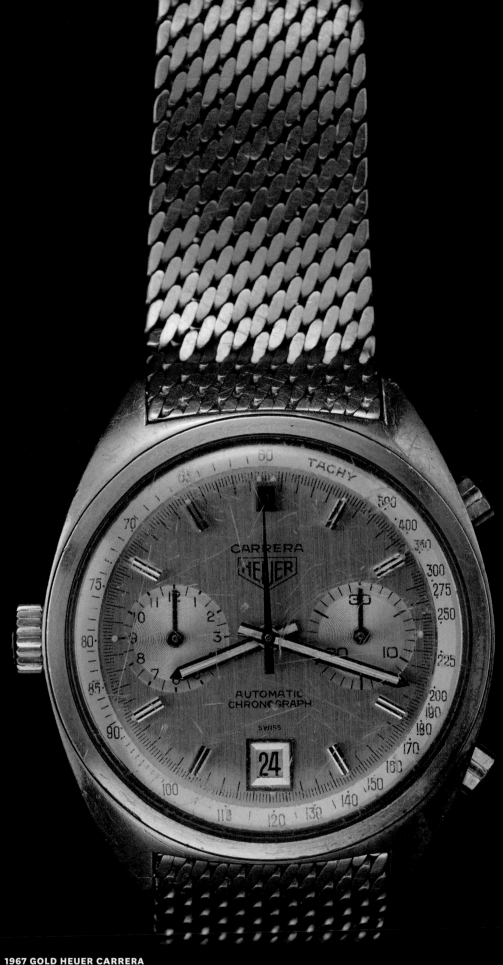

1967 GOLD HEUER CARRERA
PILOT REFERENCE 1158CH

MARIO ANDRETTI

RACING LEGEND

1967 GOLD HEUER CARRERA PILOT REFERENCE 1158CH, ORFINA PORSCHE DESIGN, FISCHER ANCRE 15 RUBIS & HEUER AUTAVIA

I've always been a watch guy, to some degree. My first watch was given to me by my uncle when we were still living in a refugee camp in Italy. I wanted a watch so bad! He gave me and my twin brother, Aldo, each a Fischer watch for our thirteenth birthday.

When I was on the racing circuit, I always took a briefcase with four or five watches—I'd change them like belts! It was stupid; I had watches stolen from me twice in Italy, another three or four from a hotel in Montreal, including a gorgeous one-of-a-kind Gérald Genta. A Formula 1 representative gave me a Porsche Design watch in Rio, and the very first time I wore it, I fell asleep on the beach after practice and it was stolen right off my wrist! I told the story to my Swiss and German friends in the press, and Porsche replaced it with another one, which I wore racing, too—that was in 1978, my Formula 1 World Championship year.

Actually, almost every watch I have was given to me. In racing, watches can stand in for trophies; I received a Heuer Autavia from *Motor Age* magazine, which was the sponsor for the qualifying event of the 1967 Indianapolis 500. In the seventies, Clay Regazzoni, another Ferrari Formula 1 driver, had a Heuer, and I was always nudging him about it. Jack Heuer was very good friends with Clay, so Heuer gave me the same watch. I have watches from Franck Muller at Le Mans, in 1995, a Heuer from when I was inducted into the Motorsports Hall of Fame in London, a Rolex from the 24 Hours of Daytona. I've just kind of kept them in a box; this interview gave me a good excuse to go through them all and say, "Hey, I remember that one! And that one!"

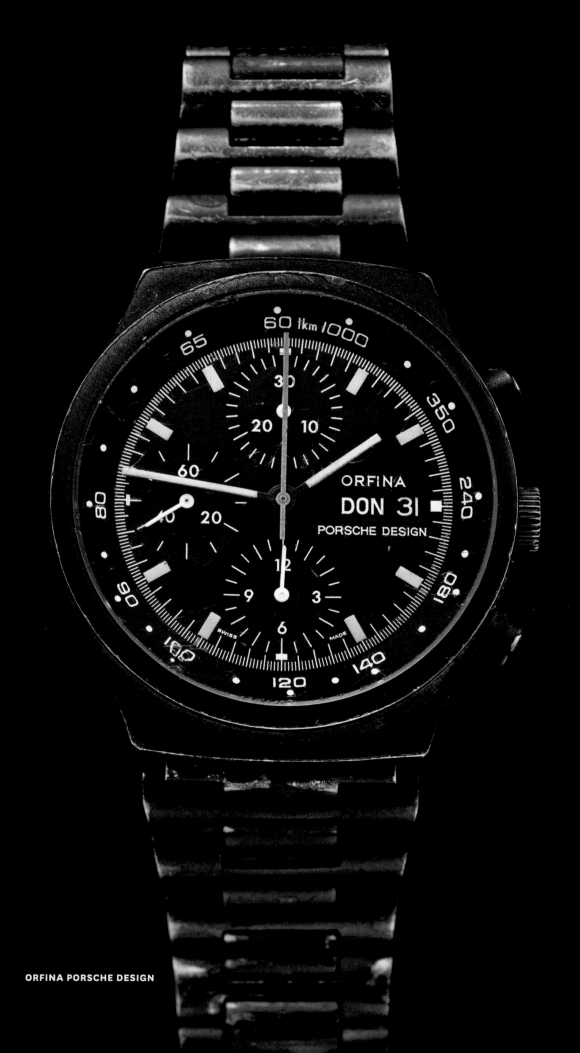

ORFINA PORSCHE DESIGN

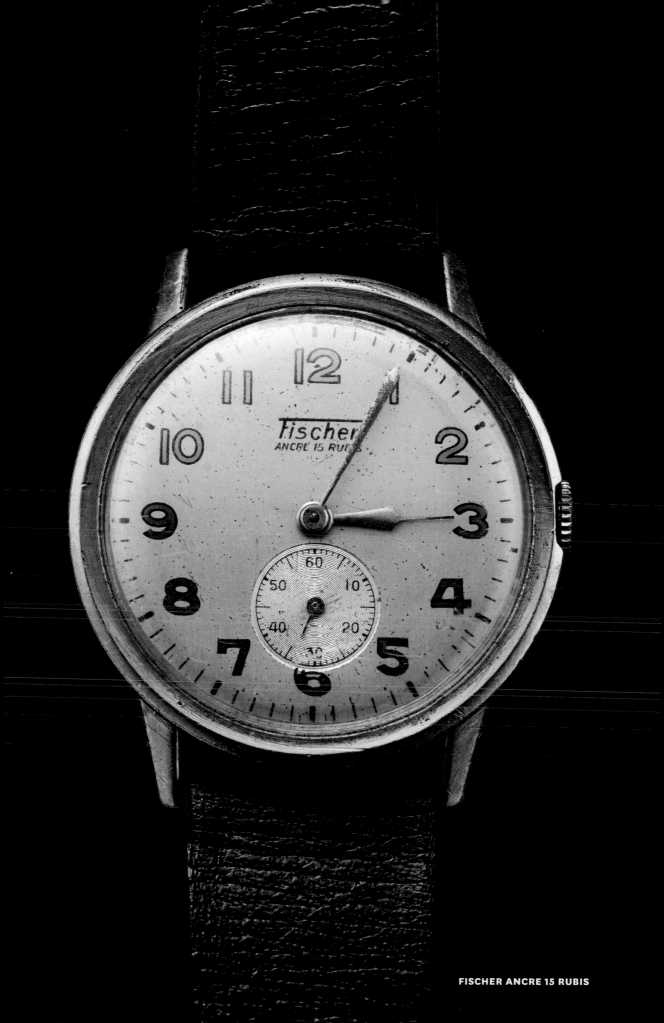

FISCHER ANCRE 15 RUBIS

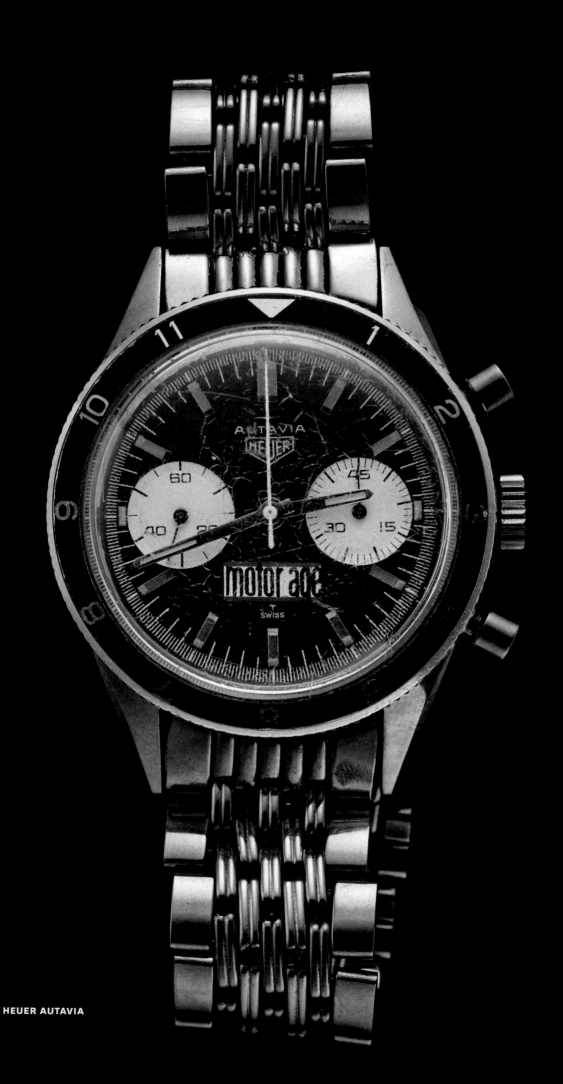

HEUER AUTAVIA

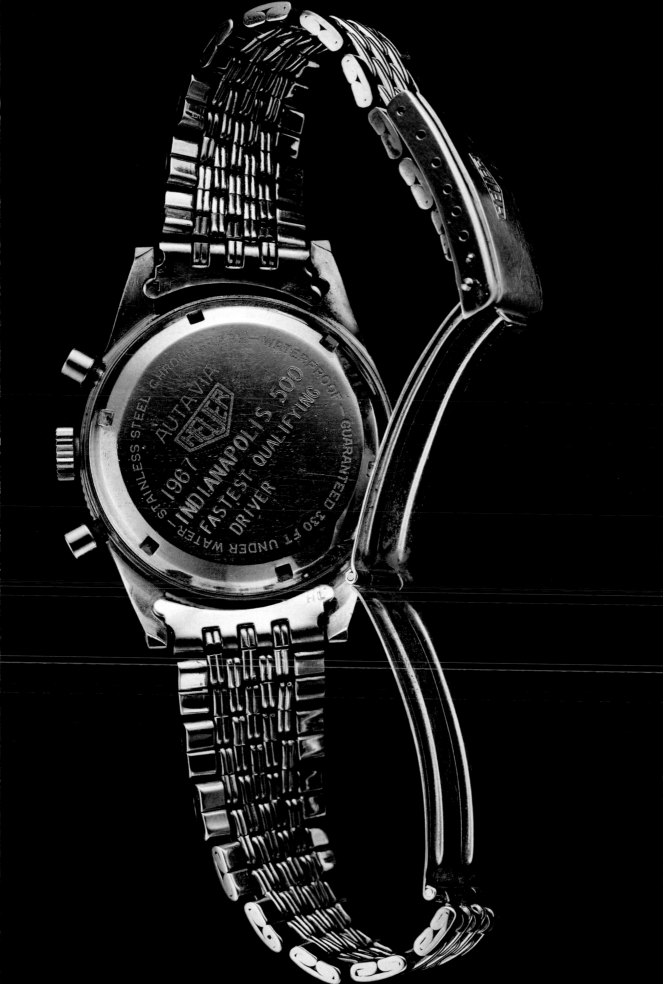

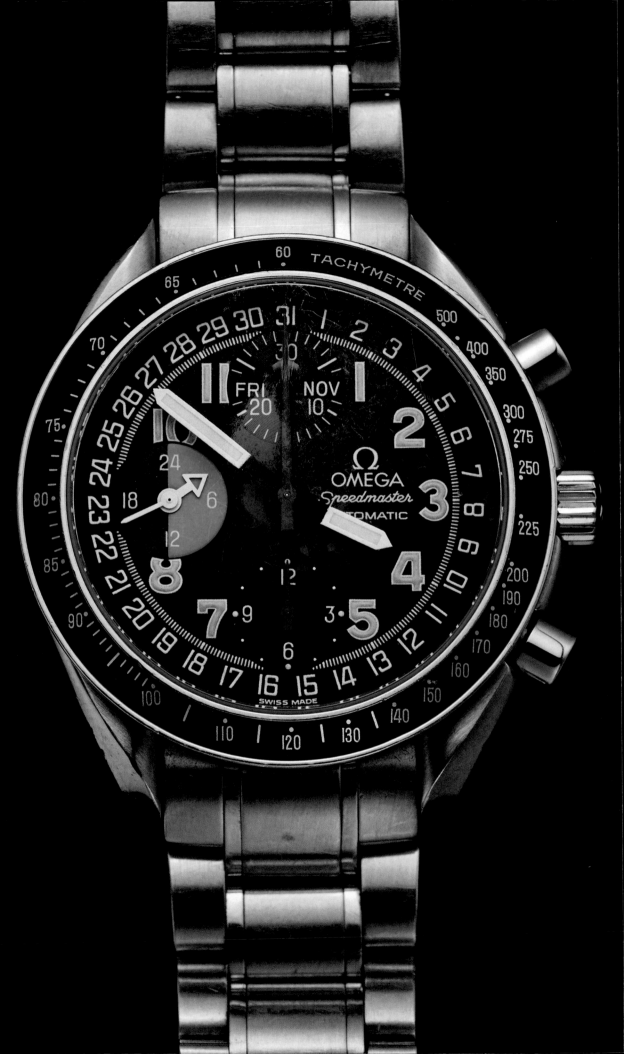

BENJAMIN CLYMER

FOUNDER & EXECUTIVE EDITOR, HODINKEE

OMEGA SPEEDMASTER MARK 40

My obsession with watches, with mechanical things in general, is completely organic. My father was a photographer and had a dark-room in our basement, and he gave me a light meter when I was six. I didn't really understand what it was; I just liked this small handheld thing with a gauge on it, and I started collecting light meters, buying them at garage sales and places like that. Then, in Boy Scouts, I became interested in compasses. The natural progression led me to the wristwatch—another cool, small handheld thing with gauges and dials on it.

When I was growing up, my grandfather was my idol, my hero. He was just this great guy whom I really looked up to. He had built up a few businesses and made a name for himself with a cigarette lighter company in the late sixties, and I admired so much about him. He felt the same connection with me; we were kindred spirits.

My grandfather wasn't a collector, but he was into watches. He knew enough to get the Antiquorum catalog. One day, when I was fifteen or sixteen, he said to me, unprovoked, "You know, I want you to have this." Then he took this Omega off his wrist and handed it to me. I was just blown away.

It's an Omega Speedmaster Mark 40, an early-nineties watch with a Valjoux-based movement—not, ultimately, a very high-end movement, but back then to see a chronograph with a triple calendar, with a date, in that size, was uncommon. And the use of bright color in the nineties was also rare. It's probably what attracted my grandfather to it, and it's certainly what keeps me interested in it today, even now that I've seen the pinnacles of horology.

I became instantly more interested in watches after that. But it wasn't a direct path to where I am now; other than selling watches, which I didn't want to do, I didn't know there was a business to this,

"One day, when I was fifteen or sixteen, my grandfather said to me, unprovoked, 'You know, I want you to have this.' Then he took this Omega off his wrist and handed it to me. I was just blown away."

—BENJAMIN CLYMER

that entrepreneurship or the media space was an option. Where I grew up, you became a lawyer or a banker or a consultant, so I went the traditional route, into strategy consulting at a big Swiss bank. In 2008, as the financial world was going straight downhill, I was sitting in a suit and tie in a cubicle in Weehawken, New Jersey, writing a Tumblr blog about this watch my grandfather had given me and a Rolex Submariner and other watches I liked. At the time, nobody was covering this stuff; I mean, this wasn't GQ, it wasn't Esquire, it was just me reading the Christie's catalog and Antiquorum and talking about things I discovered, saying, "Hey, this watch belonged to Steve McQueen!"

But within the first six months, an editor from a major men's fashion site reached out and said he'd been following the Tumblr. "You're the first guy under the age of fifty to be writing about these old watches," he said, "particularly with something to say about them. Can I interview you?" We ended up doing a story: five watches to look for if you're a younger guy interested in getting into vintage watches. And off it went from there.

I started Hodinkee in 2008, shortly before my grandfather passed away. But he got to see the first six months of, well, whatever it was back then—which, really, wasn't much. But that's what makes this watch so important: beyond the fact that it was his, it has given me this life I literally could not have imagined and that I love so much. I truly enjoy my career, and without this watch, none of this would have been possible.

FROM THE
CARTIER ARCHIVES

I reached out to Cartier about visiting their archives first, because the Cartier Santos-Dumont was very important to the story of the wristwatch, and also to this book. When I was in Geneva, they arranged for me to visit—but they never would tell me the address. Instead, they said, "A car will come for you at this specific time and drop you off at the location." It was a very polite version of being hooded in the back of a van and whisked away to a secret location! And the building itself, which was a former private banking facility, played into that cloak-and-dagger secrecy and security, with retinal scans and air-lock vaults. I was with friends who work for Cartier and had never been inside. But once you're in, you're working with the sweetest, most gentle and amazing people—archivists who would run around and track down old Cartier ads I remembered, or pull out trays of watches that once belonged to world-famous celebrities like Fred Astaire and Alain Delon. Their enthusiasm was infectious. I left with such an appreciation for the brand's craftsmanship and sense of material—a simple, flawless elegance in their dials and metals and font choices—that I immediately went out and bought my first Cartier piece.

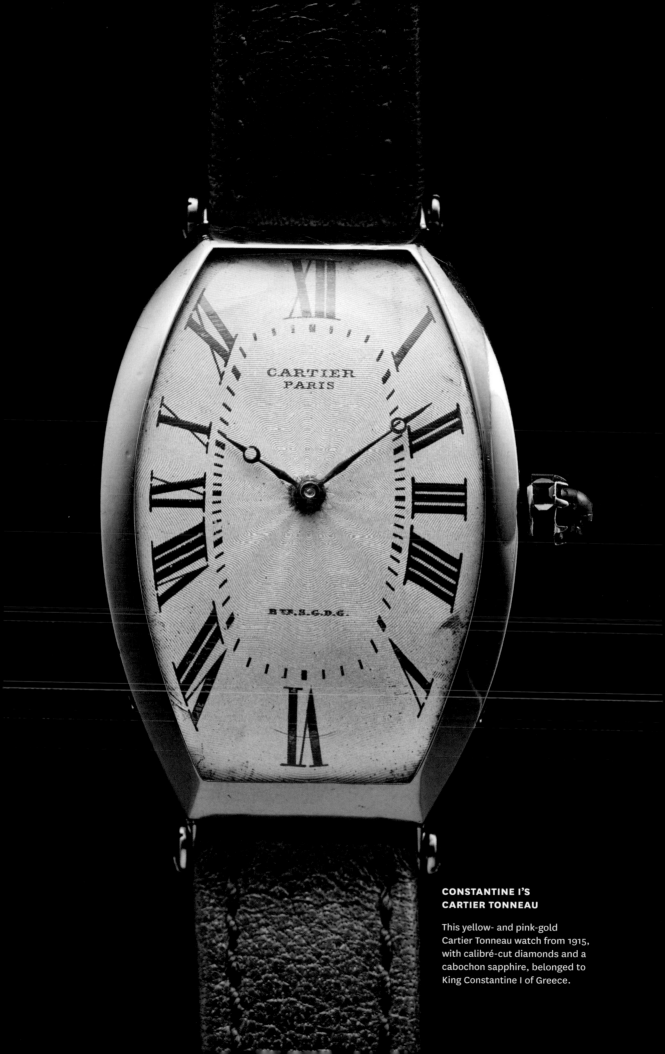

CONSTANTINE I'S CARTIER TONNEAU

This yellow- and pink-gold Cartier Tonneau watch from 1915, with calibré-cut diamonds and a cabochon sapphire, belonged to King Constantine I of Greece.

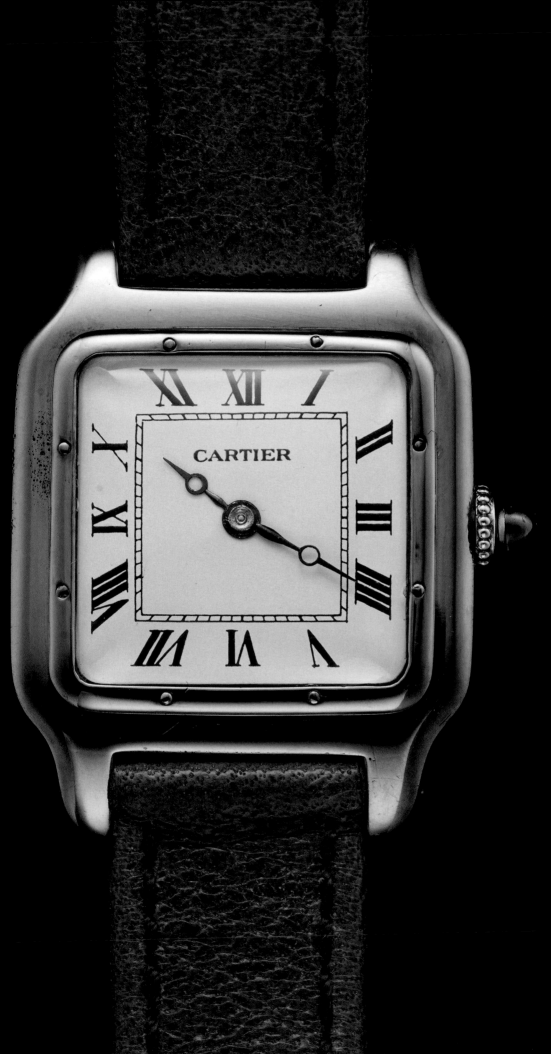

What you see here could be considered the beginning to every story in this book. This is not just the first pilot's watch (though it could be considered that) but, in fact, is also the earliest wristwatch to capture the imagination of men across the world.

The dashing Brazilian Alberto Santos-Dumont was a pioneer of early aviation, becoming the first person, on October 23, 1906, to successfully pilot a fixed-wheel, heavier-than-air aircraft that could take off and land under its own power. Two years earlier, his friend the watchmaker Louis Cartier had created a watch specifically for Santos-Dumont, to help him tell time while flying. While pocket watches were the style of the day for men, Santos-Dumont could not keep his hands on the wheel of his flying machine and check his pocket watch at the same time; Cartier invented a small timepiece that attached to the wrist with a leather strap, and gifted the new "Cartier Santos-Dumont" wristwatch to his famous aviator friend, who never flew without it. When his 1906 feat confirmed Santos-Dumont as a celebrity sensation, his picture appeared in newspapers across Europe—and he just as quickly garnered attention for the wrist-worn watch.

While Patek Philippe is credited with inventing the wristwatch, the style was largely thought of as a timepiece for women. It was not until the Cartier Santos-Dumont that men began equating the wristwatch with exploits of daring and courage, and imbuing them with all manner of romance and nostalgia—a feeling any true watch lover knows all too well.

If you've ever wondered where this crazy passion for wristwatches all began,

MODELE DEPOSE

9/7/81

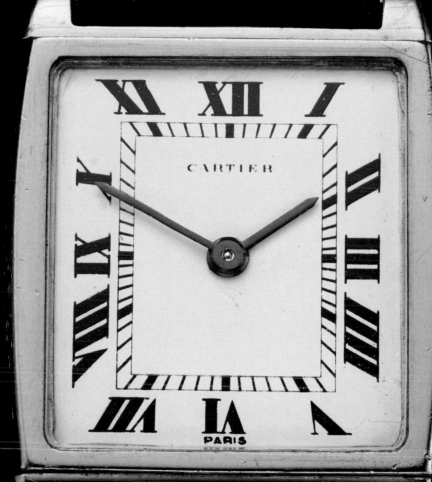

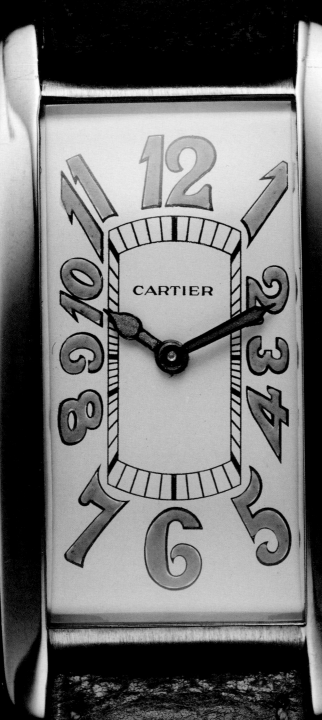

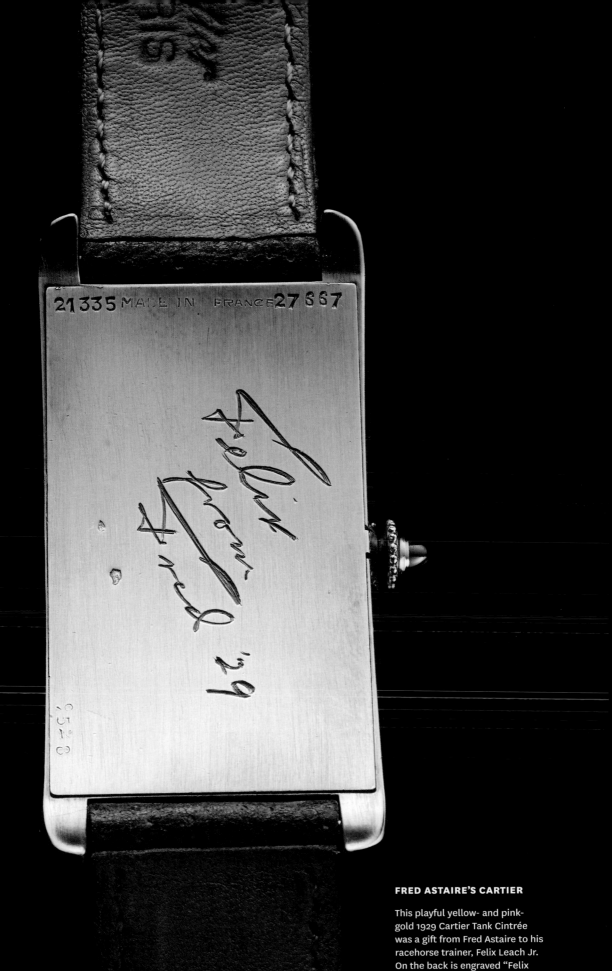

FRED ASTAIRE'S CARTIER

This playful yellow- and pink-
gold 1929 Cartier Tank Cintrée
was a gift from Fred Astaire to his
racehorse trainer, Felix Leach Jr.
On the back is engraved "Felix
from Fred '29."

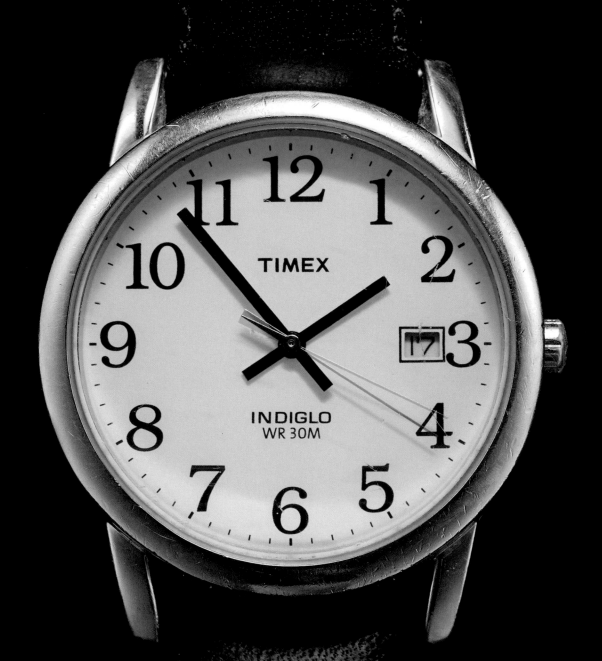

DIMITRI DIMITROV

MAÎTRE D', THE TOWER BAR AT THE SUNSET TOWER HOTEL

TIMEX INDIGLO

One night a couple of years ago, the restaurant was jam-packed, and Bill Murray walks in with some other people—he's always impromptu—so I scramble to find them a place to sit. We head toward one of the coves where it's dark, and he asks, "What time is it?" So I look at my watch and tell him it's 8:40 or so. Then he says, "Let me see your watch."

I had on an old Baume & Mercier, a classic. It's always semidark in the restaurant, though, so it can be difficult to see the hands. Bill says, "That's garbage—it's no good!" And I reply, "Bill, it shows me the time, right?" He says, "Sure, it shows the time, but it's no good in the dark." Then he removes the Timex from his wrist and says, "Take this! Because, you see . . ." He touches the button, and it glows. "Take it. You need this!"

I thanked him for his generosity but told him I couldn't accept it, and he replied, "Don't worry about that—this is yours; it's a gift from me."

Just a couple of nights ago, he called me from his room and said, "Dimitri, what time is it?" I told him the time and he just laughed, because he knew I was looking at his watch, his gift, in the dark.

It's a simple watch, functional, no problems. But you know, most every watch in the world, even the really old ones, keeps very good time—so what's the difference between all those watches? It's the stories behind them. And I have this amazing story that I've told a thousand times. When anyone asks, "Why do you wear that watch?" I reply, "Well, my friend Bill Murray gave this to me, so . . ."

KIKUO IBE

CREATOR, CASIO G-SHOCK

CASIO G-SHOCK

When I joined Casio, the company had just started making digital watches, so I was keen to develop that business, which I felt was the future.

I really wanted to create a new watch device—a tough watch and a digital watch. The ideas came from existing products and things: a car tire, a caterpillar's body. I asked myself what kind of design was needed, and what kind of basic function it should have. These were early considerations, but the starting point was to make a tough watch.

The G-Shock launched in April 1983 and came to the United States the next year. The only market it was successful in at first was America; one of the biggest reasons it's now accepted in the global market was its success in the U.S. market. I was actually surprised it took off—thirty years ago, the watch trend was for very small and slim watches. This was the opposite of that.

But no one gets tired of this design. It's still fantastic; it still looks current. When I'm asked if I would have done anything differently to the original design, I think, "No, not as long as I'm not bored with it in thirty years."

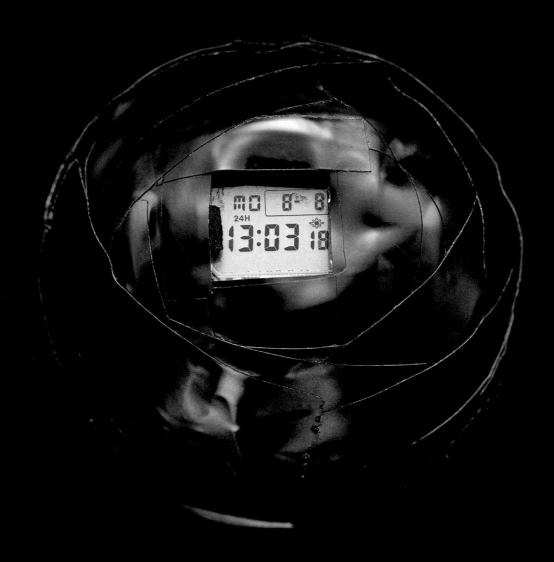

PROTOTYPE OF MODULE

This early, softball-like prototype for
the original G-Shock case was meant
to isolate the timekeeping mechanism
from concussion. Casio engineer and
G-Shock developer Kikuo Ibe got the
idea to house the movement inside a
resilient structure after seeing a girl on a
playground bouncing a rubber ball. Ibe
tested at least two hundred prototypes
for impact resistance by tossing them
out of the third-story men's bathroom
window at Casio's research and
development center in Tokyo.

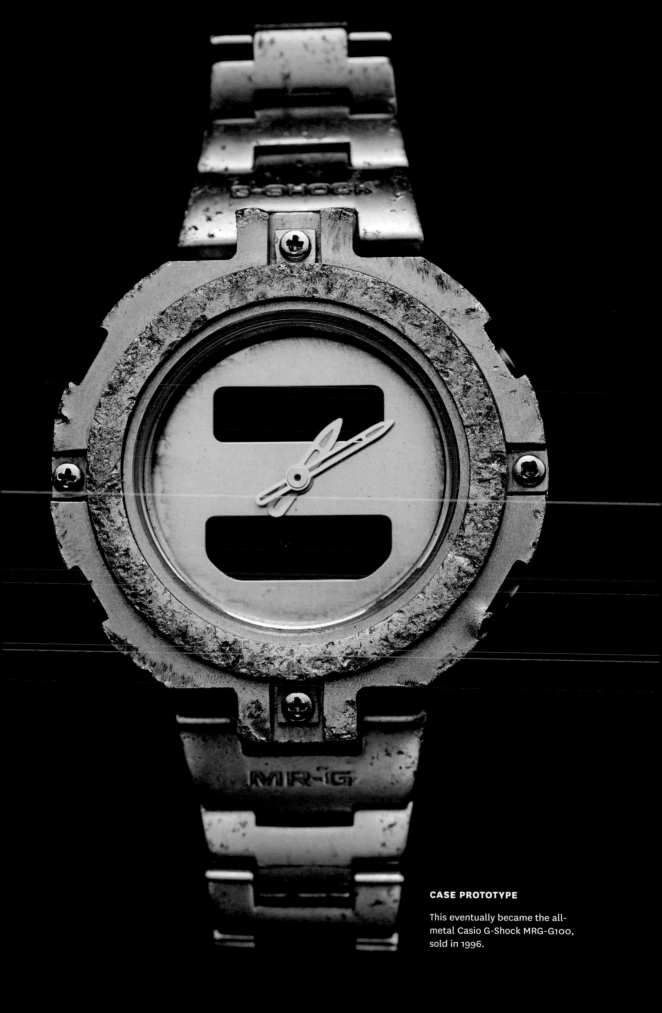

CASE PROTOTYPE

This eventually became the all-metal Casio G-Shock MRG-G100, sold in 1996.

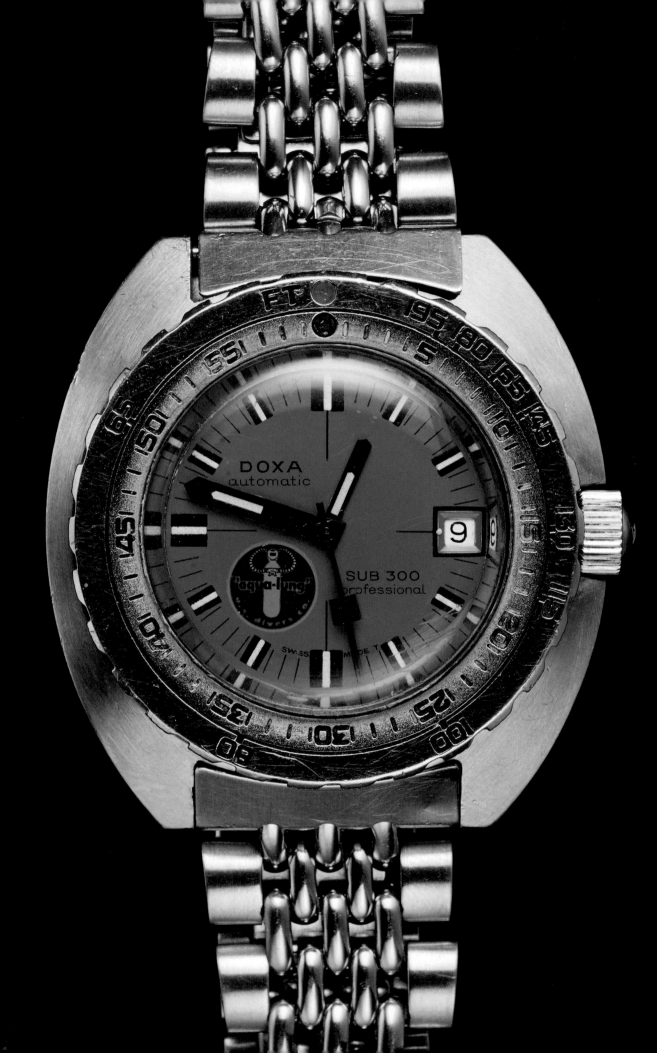

JAMES LAMDIN

FOUNDER, ANALOG/SHIFT

**1967 DOXA SUB 300
PROFESSIONAL "BLACK LUNG"**

Even as a child I knew that somewhere, someday, I was going to appreciate timepieces. It started with my grandfather—not from a single watch that was passed down, but more of an overall appreciation. He wasn't a wealthy man, but the objects in his life were exclusively of high quality, whether it was clothing and artwork or booze and music. I remember walking into his house as a kid and saying, "What's this new piece of art about?" and he'd say, "I bought it in 1973 in this little shop in New Zealand—we'd just had these beautiful roast beef sandwiches, and the shop owner's daughter was really cute, and they had a dog." I came to associate his possessions with storytelling, and while I didn't inherit any spectacular watches from him, the interest started there in earnest.

I was more rugged in my youth, and wore a lot of digital watches—Timex Ironmans and Luminox Navy SEALs—because I fancied myself a survivalist and outdoorsman. The first time I ever encountered the name "Doxa" was on the pages of a Clive Cussler adventure novel that I read in elementary school. Cussler became my favorite writer of escapist fiction; his main character, Dirk Pitt, is the quintessential cross between Indiana Jones, James Bond, and Jacques Cousteau. And he wears an orange-faced Doxa diving watch.

After my grandfather passed, I was determined to find "my" watch. And a light went off: I knew about the Doxa, even though I had no idea what it looked like. And at the time, the Internet wasn't as robust as it is today; there weren't online communities of watch enthusiasts, and eBay was in its infancy. So I had a lot of work to do, and mostly it was researching with older collectors—people who knew the brand and even Clive Cussler's personal anecdotes. (He actually got a Doxa watch from a dive shop he was working in when

writing his first novel, *The Mediterranean Caper*, and he simply wrote it into the book.)

As a collector, I've always been driven by authentic stories and real history. I appreciate aesthetics and fashion watches to a degree, but I really enjoy watches that were designed for a purpose. Doxa has a rich history with tool watches. They're a Swiss company, older than Rolex. They had some early success with pocket watches that were extremely accurate, and went on to introduce an eight-day power-reserve dashboard clock for early cars—if you owned the first Mercedes-Benz or Ford and you wanted a clock in it, most likely that would be a Doxa. The company has a history of supplying the military, as well, but by the fifties and sixties, the company wasn't as relevant.

But sport watches were becoming a thing then, and the director of Doxa at the time was keen on the new sport of scuba diving, so he developed an all-new watch that was functional and practical for divers—looks be damned! While the Doxa Sub 300 wasn't the world's first diving watch, it's arguably the first purpose-built diving watch for both amateur and professional divers. Things like bright, high-visibility dials in orange and yellow, the unidirectional rotating bezel, the diver's extension clasps—Doxa pioneered those.

The road to finding my first Doxa took several years. Ultimately, this watch found me. A guy in California had been given a Doxa Sub 300 "black lung" by his father, who was an underwater cameraman on the James Bond film *Thunderball*, among others. His father had purchased the watch in 1968 at a dive shop in Florida. Eventually he gave it to his son, who wore it for a short while before putting it in a desk drawer and forgetting about it for thirty years. When he was packing up to move to Arizona, he came across it again. He wanted to find out more about the watch and its origins, so he did some research. He came across my name because I had been quoted several times on the subject of Doxa, and he reached out to me. The few blurry photos he sent me of the watch got me really excited; I encouraged him to send it to me in New York, which he did. I authenticated it, then spoke to him on the phone about what it was worth. And then I waited for him to ask that next question: "Do you want to buy it?"

This happened just as I was starting my company, and while it wasn't a mind-blowing expenditure, keeping a watch for myself at that stage was a luxury. And a vintage watch is the ultimate luxury— it's owning something that no one else has, but it's also being the keeper of its story. It's a book; there are chapters. And then you have that object and you write your own chapters into it. Doxas aren't impossibly rare watches to find, but they're certainly not every-where. I've never been the guy who buys a watch to start a fresh book, to start something new. I'd rather write my chapter into some-thing that's ongoing. Perhaps forever.

I'm crazy about these Doxas, and I wear mine all the time. I guess I've become somewhat known for Doxas. I don't want to own them all; I just really love them and want them to be saved.

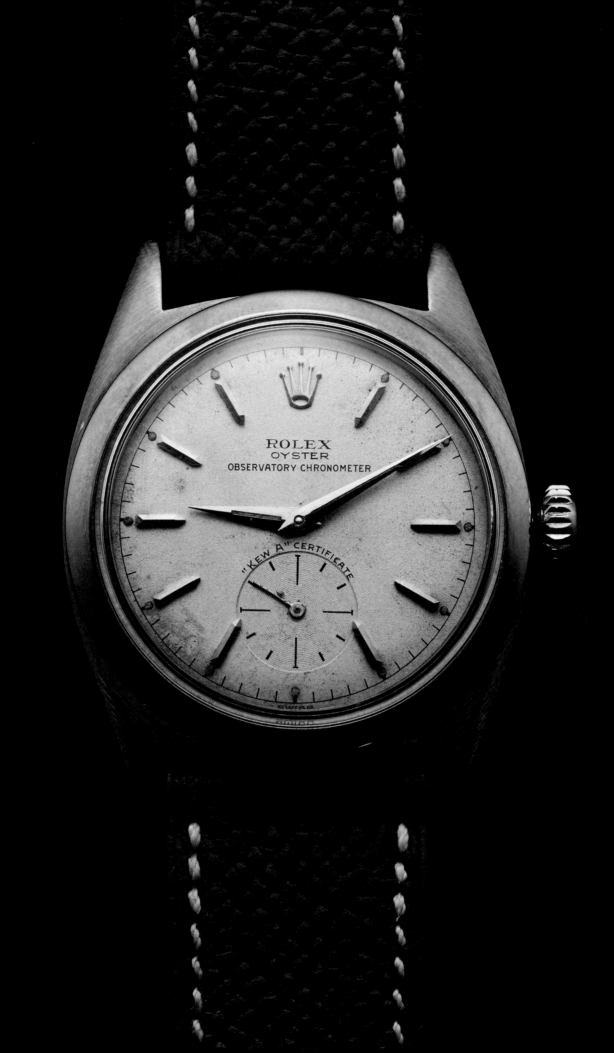

PAUL BOUTROS

HEAD OF AMERICAS & SENIOR VICE PRESIDENT, PHILLIPS

ROLEX "KEW A"
OBSERVATORY CHRONOMETER

I discovered watches at age ten, walking down Fifth Avenue with my father after a coin show. We pass by Wempe—this was back when it was on the other side of Fifth—and I'm peering into the windows, seeing these beautiful timepieces under the lights, looking magnificent. And I couldn't believe the extraordinary prices: a watch for $50,000, for $100,000. A saleslady notices us and invites us into the beautiful boutique, and she sees the sparkle in my eyes. She says, "What would you like to see, young man?" I point to an IWC Portofino Moon Phase pocket watch, $23,000, and she opens the caseback. Under the halogen lights I see the movement shining in all its glory—rubies, gold-plated bridges, the ticking large balance wheel of a pocket watch. It was love at first sight, and from then on, I had to know more. I'd get the *Wall Street Journal*, call the numbers on the advertisements, and send away for the watch catalogs from Patek Philippe, Audemars Piguet, Breguet.

My dad saw this excitement that I had and he caught on. We'd go to auctions together, to flea markets and retailers. We started our collection, me doing the research and him doing the buying, and it overtook everything else—no more coins, just 100 percent watches.

My dad came from Egypt, from a very conservative Christian culture. And I was born when he was older—forty-two—so not only was there a cultural gap, there was a generational gap. We fought about everything. But when it came to watches, there were no fights. Watches were the source of all my happy childhood memories with him.

When he passed away in 2002 and I opened the safe-deposit box that held all of our watches, I was overcome with emotion. This collection was him, it was me, it was our best memories.

I had a good career as an electrical engineer with Lockheed Martin, developing missile defense systems—I was an actual rocket scientist, believe it or not. But after my dad died, and seeing the collection we had built, my passion was reignited in a big way. I started writing about and photographing watches for fun in my spare time. I got really into the watch world again, moderating a couple of forums on TimeZone.

This watch came to me a year after my father passed away. It's one of the rarest of all Rolex references, and one of the most precise mechanical watches ever sold to the public by any brand. It was handmade and hand-finished by Rolex's top watchmaker, one in a batch of 144 meant to pass the most stringent ship's chronometer testing in the world at the time, at the Kew Observatory in England. Looking into this rare watch that I had—there are only five known examples in the world—I realized that it incorporated what's called a Guillaume balance, a very complicated component. At the time, the world didn't know that Rolex had used this, and my discovery kind of put me on the map in the collector world.

Doors started opening. People began to contact me to write and consult. There were many conversations with Christie's and other houses, and eventually I came on board with the Phillips auction house when they were opening their own watch department. This was right before I was about to get a big promotion at Lockheed and be relocated. Now I'm living my dream.

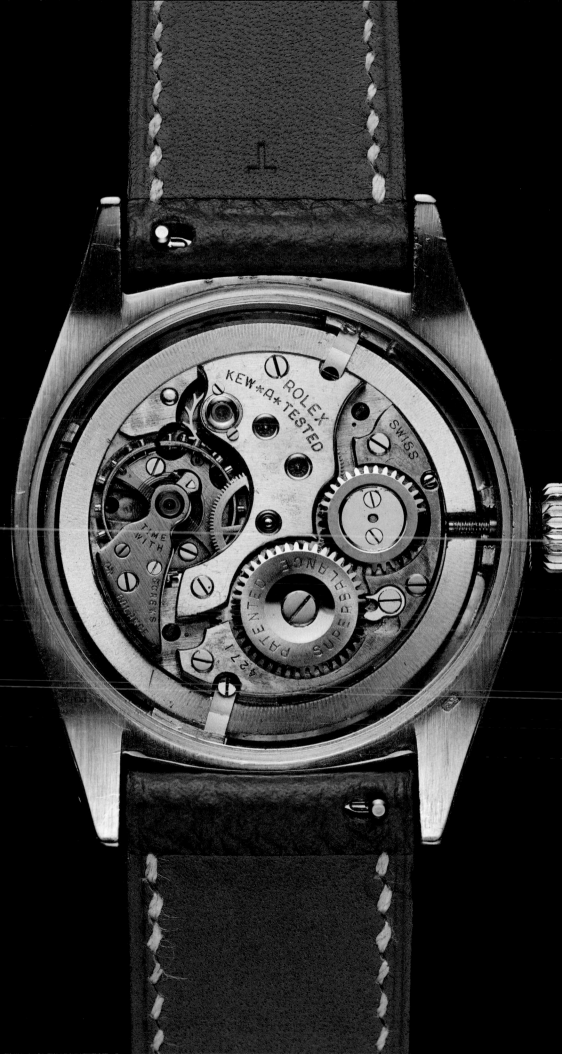

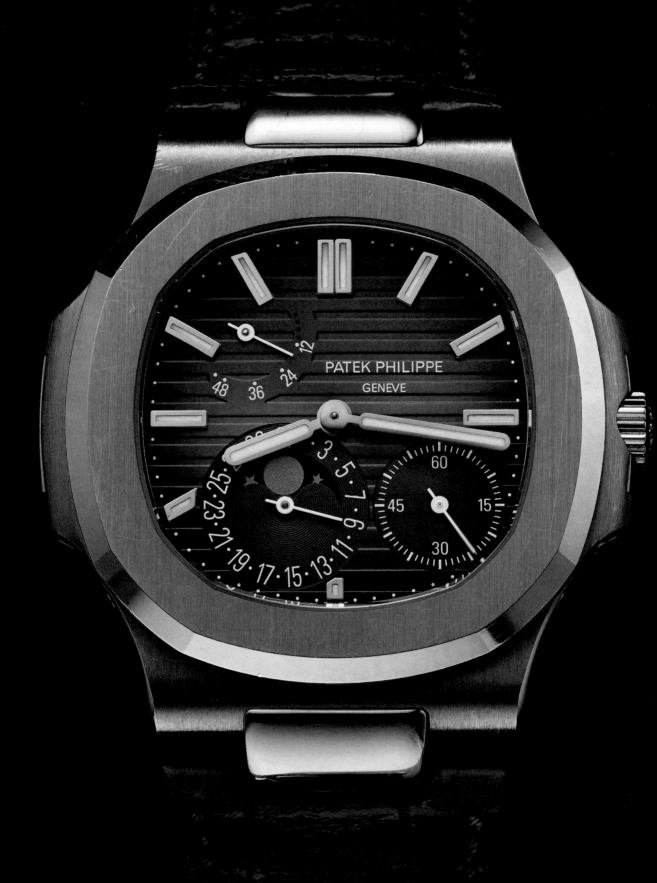

NAS

MUSICIAN & ENTREPRENEUR

**PATEK PHILIPPE NAUTILUS
REFERENCE 5712R**

When I was around seventeen years old, living in Queens, I knew a guy who had a gold Rolex Presidential. Even before I saw it, I heard lots of people talking about it. I had never seen something like that up close before. He was my first friend who had an all-gold Rolex, and something about the seriousness of it made him more of a man, you know? I've noticed through the years that many important men wore a gold Rolex just like it—Sammy Davis Jr. and Martin Luther King Jr., to name a couple.

My father never wore watches the way I wear them. No one in my family wore the type of watches I like. It just came to me; I have my own taste, a way of styling things that appeals to me.

I like to wear things that people don't know about. When you notice a man with a watch that you've only seen in a magazine, or heard about, there's something unique about the guy wearing it. If you see a guy with a lot of diamonds on his watch, the way I see it—the way I've experienced it with other people, and even myself— you know that guy likes to have a lot of fun. He's looking to have a good time.

My current favorite is a Patek Philippe Nautilus. I like the name, and I like that it's not a watch that everyone is wearing. I don't have large wrists, and the proportions and the shape fit. It's comfortable. There are no diamonds, it's rose gold, there's a leather band—it goes with everything. It works if I just want to sit with my everyday look, but if I go somewhere that requires a suit, it'll stand strong, too.

It doesn't matter what's happening in the digital world; you like what you like. The picture quality of old movies isn't great, but they're still classics, and I won't stop watching them just because movies today are high-definition. The first Jordan sneakers didn't have ankle

support like the sneakers that came after them, but I bought them when they first came out, and I buy them today. Certain things are with me forever.

They say time is an illusion, but even so, you need it. A good watch represents someone who's punctual, responsible, who has a lot on his plate. Someone who knows how to manage his time and takes life seriously, because life doesn't wait for anybody. Before you know it, you're running out of time.

"If you see a guy with a lot of diamonds on his watch, you know that guy likes to have a lot of fun. He's looking to have a good time."

—NAS

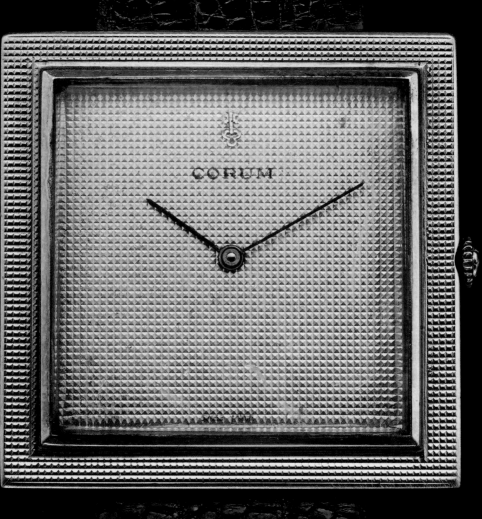

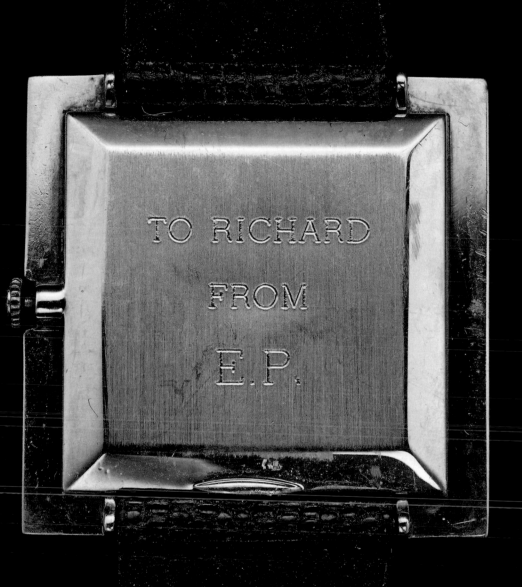

ELVIS PRESLEY'S CORUM
BUCKINGHAM REFERENCE 5971

This square-faced yellow-gold Corum
Buckingham was the King's own, until
one day he handed it to his longtime
valet, bodyguard, and movie stand-in,
Richard Davis, complaining that there
was something wrong with the watch.
When Davis turned it over to inspect
it, he saw the inscription, "To Richard
from E.P." Perhaps Elvis Presley meant
it to be Davis's "Good Luck Charm."

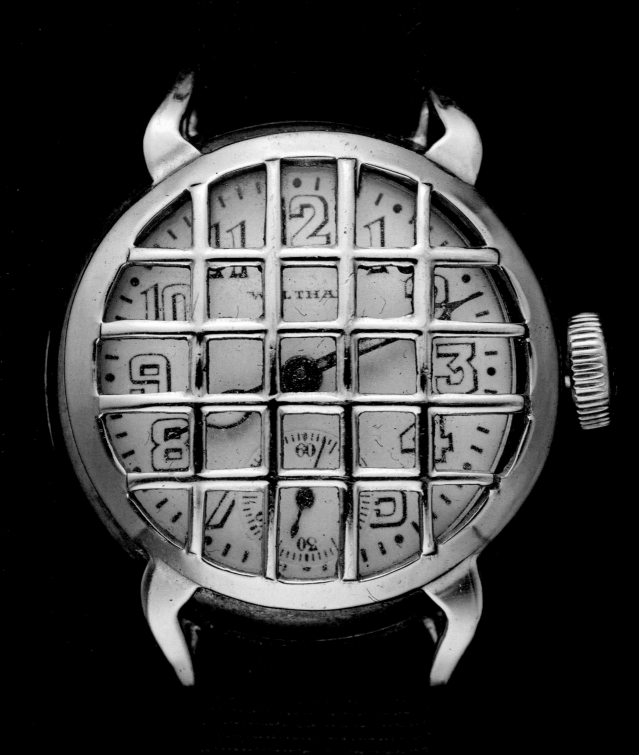

DR. JACK CARLSON

ARCHAEOLOGIST & AUTHOR

1914 WALTHAM TRENCH WATCH

My PhD is in Roman and Chinese archaeology—stuff that's a lot older than my trench watch from 1914. But I love the idea of artifact, the idea of understanding history through objects.

I grew up about five minutes from the Waltham watch factory in Waltham, Massachusetts. Every time I'd walk around town, or get a bite to eat or a cup of coffee, I'd notice that everything was named after the watch industry—Watch City Brewing or something like that—or had watches as logos. It was a reminder of this great American manufacturing and craftsmanship heritage, right where I lived. And a lot of these watches, historically, were being made for American soldiers in World War I.

This one has a shrapnel guard, which tells its own kind of story about the utility of the watch, and about its history. In a way, the idea is morbidly humorous—you'll get blown up, but the crystal won't get cracked—but it's also very serious. There's a sense of gravity to it.

There's a term we use in archaeology, "material biography," which refers to the life story of an object. So just as we can talk about what happened to the person who wore this watch, we can also imagine what happened to the watch itself—where was it manufactured, where has it been in its life, what has it seen?

I didn't inherit this watch; I don't have a personal connection with it in that way. But when I'm excavating in Italy and find a coin or a piece of pottery, I don't necessarily have a personal connection with that object, either. Part of the joy for me is imagining the stories behind these artifacts.

AARON SIGMOND

COLUMNIST & AUTHOR

ELGIN

Like most twentieth-century Eastern European immigrants, my grandfather came to America between World War I and World War II, in the late twenties, and went through Ellis Island. But instead of settling in Brooklyn or on the Lower East Side, as many Russian and Polish Jews did, he continued straight on to Chicago. His father and two of his brothers were already there, and they all went into business together with a car dealership. One of the very first purchases he made in the United States was this Elgin watch.

I think the Elgin brand symbolized two things to him: it represented life in America—a new life in a new land—and it represented Chicago, because Elgin was based there.

My grandfather wore this watch for special occasions: weddings and bar mitzvahs and high holidays. Then back in the drawer it went. At my bar mitzvah, my grandparents gave me all the traditional stuff—a bible, a pen, and some money—but I told my grandfather that what I really, really wanted was that watch.

When my grandfather died, my grandmother performed the sad ritual of doling out his personal effects: a signet ring, a star sapphire ring, and a couple of really nice watches. By that time, the Elgin had seen better days; it didn't have a strap, and some of the numbers had fallen off the dial. Nobody else really wanted the watch. I thought they were all crazy because, to me, it was the embodiment of this man's entire life! It told his story.

In terms of monetary value, this is the least valuable watch I have in my collection. But it's the dearest to me. And I wear it like my grandfather did, only on special occasions.

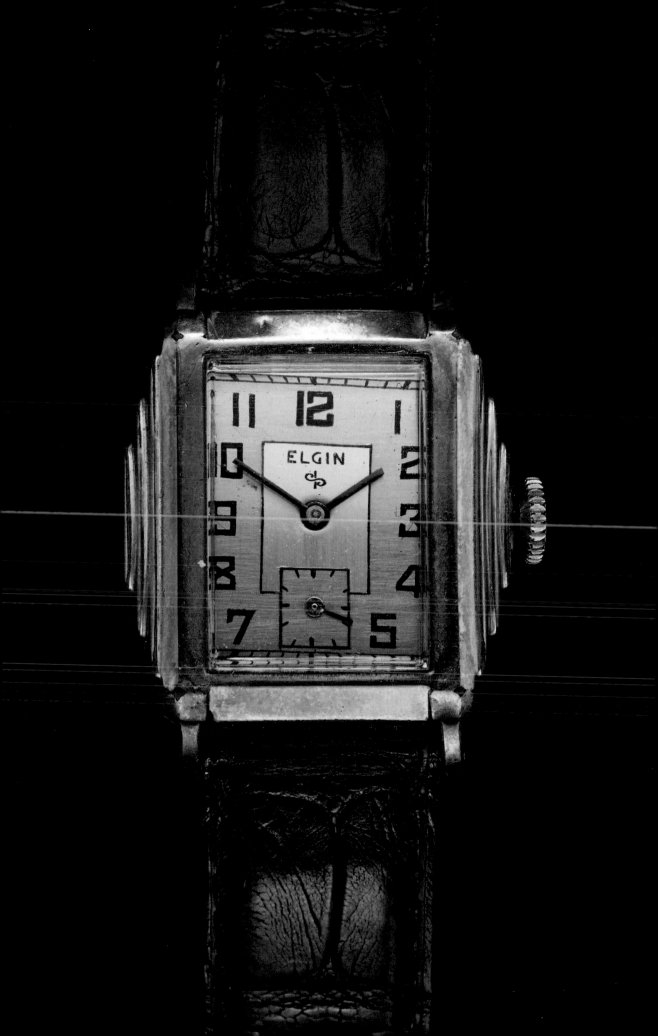

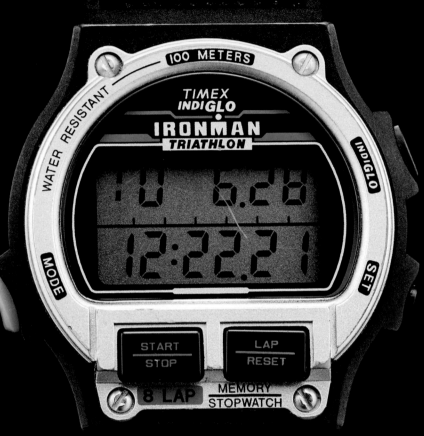

MAX WASTLER

FOUNDER, *ALL PLAIDOUT* BLOG

TIMEX IRONMAN

I got this watch from my camp counselor, Matt, when I was ten years old. I just thought he was so cool. I looked up to him in every way. He played college baseball in Texas, and he shared some of his insider tips with me. He also got me geeked out on things like Patagonia Snap-Ts and baggie shorts, and this killer Ironman watch with a Velcro strap. He would time me in swimming on that watch, and I would always tell him how incredible it was. For four summers, I thought about the watch and talked to him about the watch. At the end of our last summer together, he gave it to me.

Camp was where I first learned orienteering, where I learned how to dive, how to camp, how to set up a tent and make a fire. All of the things that play into every adventure I now have out in the wilderness tie back to that watch; it's an immediate reminder of every great outdoor experience I've ever had.

Funnily enough, what I was really attracted to as a kid was the Velcro strap. When Velcro first came out, it was a huge thing. It felt like, here's a thing that's existed for only a short time, something that man invented in our lifetime. It's still pretty remarkable. And it's part of the utilitarianism of the watch, the base quality of it—it's just a simple, clean, classic digital watch. It has a great shape, a great colorway; it doesn't overdo any aspect. And compared to the Casio WR I was wearing before I got the Ironman, it had the added functionalities of the brighter Indiglo light, the start-stop, and an alarm. I used that as my alarm clock for so long.

Even now, it feels like one of those slap bracelets from the nineties—you slap it on and it fits around the wrist so perfectly. I love the chunkiness of it, how it stays put all day. Wearing it helps me remember the adventurer inside of me, even in the middle of a city.

FROM THE
TAG HEUER ARCHIVES

The Heuer visit, for me, was about the famous Steve McQueen Heuer Monaco watch from the 1971 film *Le Mans*. The archives had one of the three that were used in the movie, and when you hold it in your hands, it's just amazing—it's one of the most iconic and instantly recognizable watches in the world.

Heuer is all about motorsports. They had Formula 1 driver Jo Siffert's watch, another iconic piece; an example of the gold Heuers that were gifted to winning Ferrari drivers; dash-mounted timers; obscure stopwatches; and all these crazy watches that Brazilian F1 legend Ayrton Senna designed himself.

The Heuer collection is just incredible. And unlike a lot of other archives, it is an actual museum and exhibition space, although it's only open once a year for the locals of La Chaux-de-Fonds, where the museum is located. We were grateful to have exclusive access to these extraordinary watches.

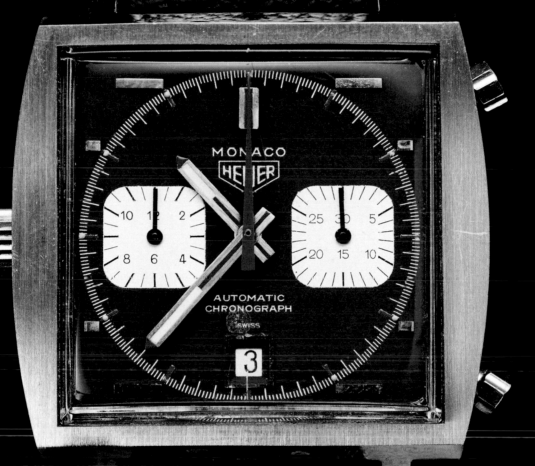

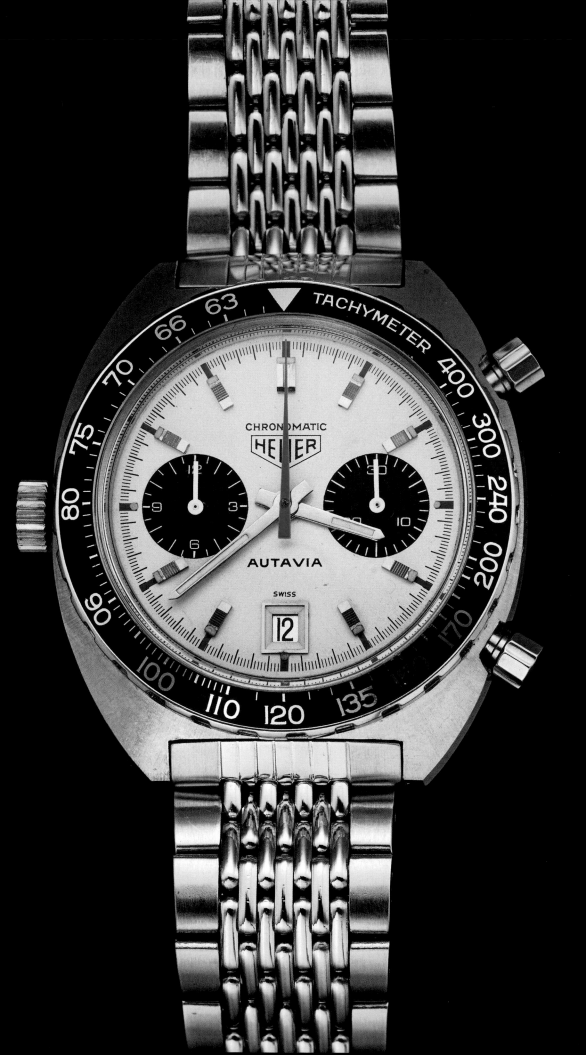

JO SIFFERT'S HEUER AUTAVIA

It's because of Jo Siffert and this watch that Steve McQueen chose to wear the famed blue Heuer Monaco in the movie *Le Mans*. In addition to being a driver, Siffert owned a sports-car rental company. The property master of *Le Mans* asked him to supply Porsches for the movie, and that's when he was introduced to McQueen. McQueen wanted to wear the same racing uniform as Jo, which had a prominent Heuer Chronograph patch on the right shoulder. To match the gear, he wore a Heuer Chronograph, hence the blue Monaco, catapulting it to cult status.

MATT HRANEK

EDITOR, AUTHOR & PHOTOGRAPHER

SEARS WINNIE THE POOH WATCH

As a kid, I wasn't a Mickey Mouse kind of guy—I was all about Winnie the Pooh. To say I was obsessed would be an understatement; I had Pooh everything: sheets, toys, pajamas . . . if it had Winnie on it, I owned it.

My paternal grandmother, Anna, gave this watch to me when I was five or six years old. At least, that's according to my mom. My grandmother bought absolutely everything out of the Sears catalog, so it's not surprising that this little manual watch came out of there, too.

My mom saved this watch for years in her jewelry box. She gave it back to me recently. When it comes to my lifelong obsession with timepieces, it's fair to say that this is the watch that started it all.

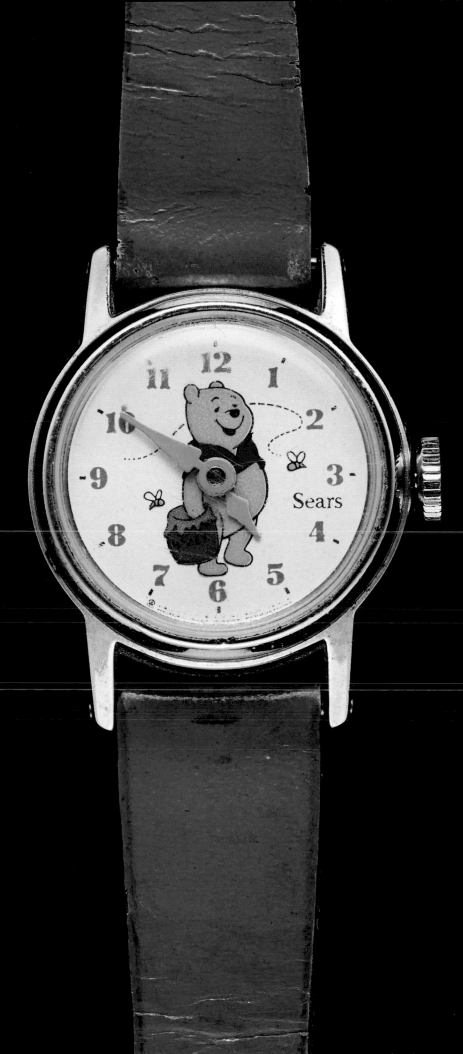

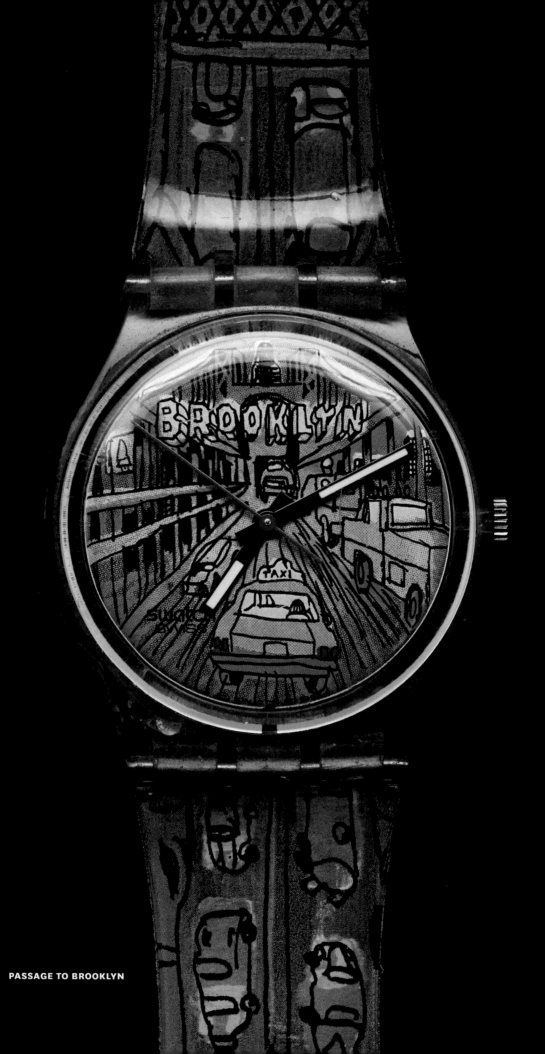

PASSAGE TO BROOKLYN

ATOM MOORE

PHOTOGRAPHER & ART DIRECTOR, ANALOG/SHIFT

NEW YORK CITY SWATCHES

When I was growing up, I wasn't particularly interested in watches. But Swatches were colorful and cool, and I wanted one. I grew up in Massachusetts and studied photography at a small state school there. When I came to New York City for my internship program in 2005, I needed a job, so I got one at the Swatch store in Times Square.

Immediately upon working there, I realized that they had a bible of every Swatch ever made. I spent my lunch breaks studying it. The art ones always caught my eye—they were my grail watches when it came to Swatch. I especially coveted the Keith Haring watches, even though they came out before my time there. They had originally retailed for $40 or $50, but were then selling for about $800 each. As someone who was just out of school, I couldn't afford to collect them. So I kind of forgot about them for a few years. Then three or four years ago I was photographing watches for an auction house, and the next thing on the block for me to shoot were the Keith Haring Swatches. I looked down and just stared at them.

By that time I was a huge watch person. My wife and I were both collecting the big brands. When these were revealed to me, I stopped in my tracks. That night, I talked to my wife about the experience and she said, "Well, we have to get these, obviously." We bid on the low end of the auction estimate, and we won.

The watches came in the condition you see today, which is not perfect, but if they were pristine, mint in the package, I would have been hesitant to take them out and wear them.

I'm buying Swatches all the time, because they're inexpensive and they're fun, so why not own them? They're like little pieces of art that you can put on your wrist.

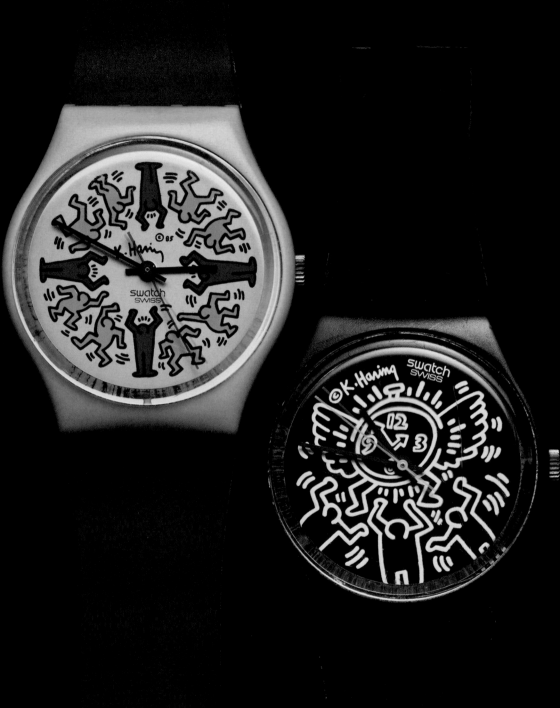

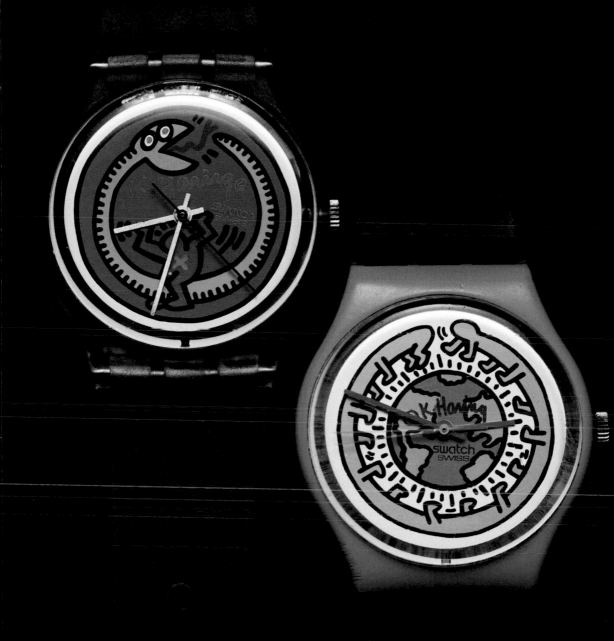

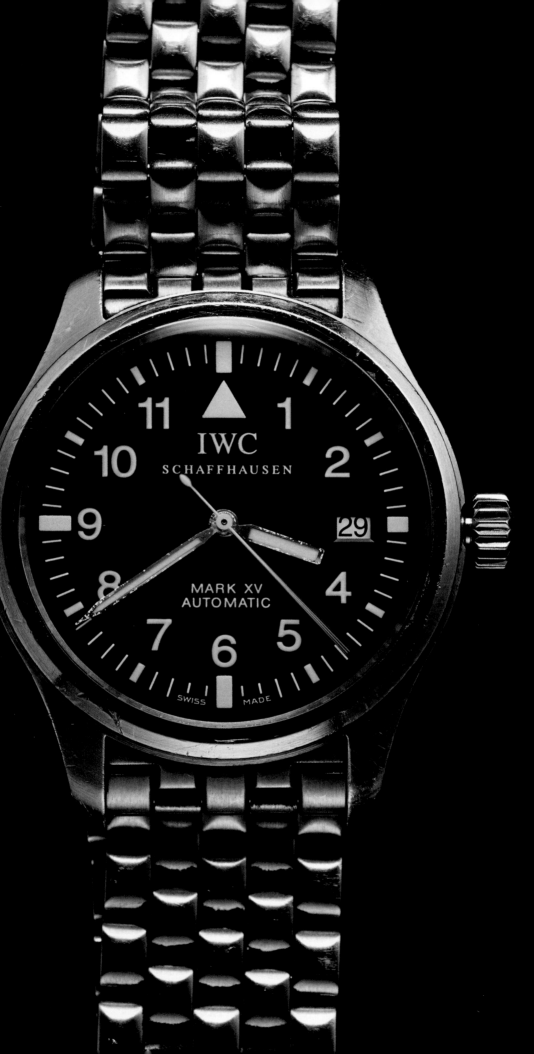

FRANK CASTRONOVO

CHEF & CO-OWNER, FRANKIES SPUNTINO GROUP

IWC MARK XV

My grandfather was an amazing guy, a working-class kid made good. He grew up in Brooklyn during the Depression. It was a tough life. He hustled, dropped out of high school, and enlisted in the army. He fought in the war, got a lot of commendations, and came out a lieutenant. He stayed in the reserves and rose all the way up to colonel. A natural leader.

And he was a collector—cars, watches, guns from the Civil and Revolutionary wars. He believed that those things stayed with you. They retained value; they were collectibles.

My daughter was born in 2000 while I was living in Germany, and my grandfather came to see us. The trip was twofold: he wanted to visit our family, of course, but he also wanted to see the country. He had fought against the Japanese in World War II but hadn't been to Germany. He was a commissioner's assistant for the New York City Department of Sanitation, and he was always impressed by Germany's efficiency and cleanliness. He was also curious about the people and the culture.

It was a tradition for my grandfather to gift jewelry and watches, especially on big occasions, so when he arrived, as expected, he asked, "What do you want?" I had already been to a couple of watch stores in Germany and told him I'd heard a lot about these watches made in Schaffhausen, Switzerland. At the time, IWC wasn't a big, popular brand. But I liked that they made all their own movements, produced everything in-house, and it was a high-quality watch that was still affordable.

We looked on the map: from Freiburg, where I was living, the drive to IWC would take about an hour and forty-five minutes by car. So we drove. It was such a beautiful trip, just my grandpa and me

"This is my everyday watch, but it's also an heirloom; it's something you pass on to your children and your grandchildren. Heirlooms make you think about the people in your life."

—FRANK CASTRONOVO

on a long drive through the Black Forest to the IWC boutique. That's where we bought this Mark XV, straight from the source.

I like its simplicity. The big numbers, the black face on the stainless steel. It's so comfortable, I don't even feel it at all. And it's a classic—you can wear it casually, but you can also dress it up. It goes with everything.

It was the first watch in my life that I'd ever picked out just for me—one that wasn't handed down. It's my everyday watch, but it's also an heirloom; it's something you pass on to your children and your grandchildren. Heirlooms make you think about the people in your life. Like my grandfather. He had impeccable taste, beautiful clothes. He smoked Cuban cigars until the day he died at eighty-six years old. He was like another father to me. I look at this watch every day, and so every day I think of Lou Dileo.

SIR EDMUND HILLARY'S
ROLEX OYSTER PERPETUAL

There are few achievements that resonate as
lastingly in the popular imagination as Sir Edmund
Hillary and Tenzing Norgay's first summit of Mount
Everest, at 29,029 feet, in 1953. On Hillary's wrist
was this unassuming Rolex Oyster Perpetual
Officially Certified Chronometer from 1950. With its
white face, dagger hands, and triangular indexes,
it bears little resemblance to the Rolex Explorer
for which it is the forebear. The watch was never
produced commercially, and was provided to
Hillary for testing purposes (Rolex was a sponsor
of the 1953 expedition). After returning from the
summit, Hillary dutifully mailed the timepiece
back to Rolex, in Switzerland, from his native New
Zealand. The time that is currently on the watch
is the exact time Hillary reached the summit. The
brand presumably tested the watch extensively
before eventually gifting this unique piece of history
to the Beyer Clock and Watch Museum in Zurich,
where it still resides today.

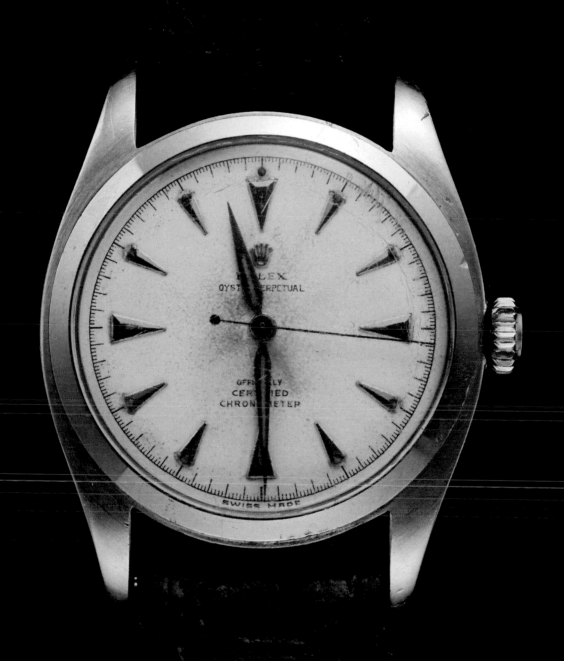

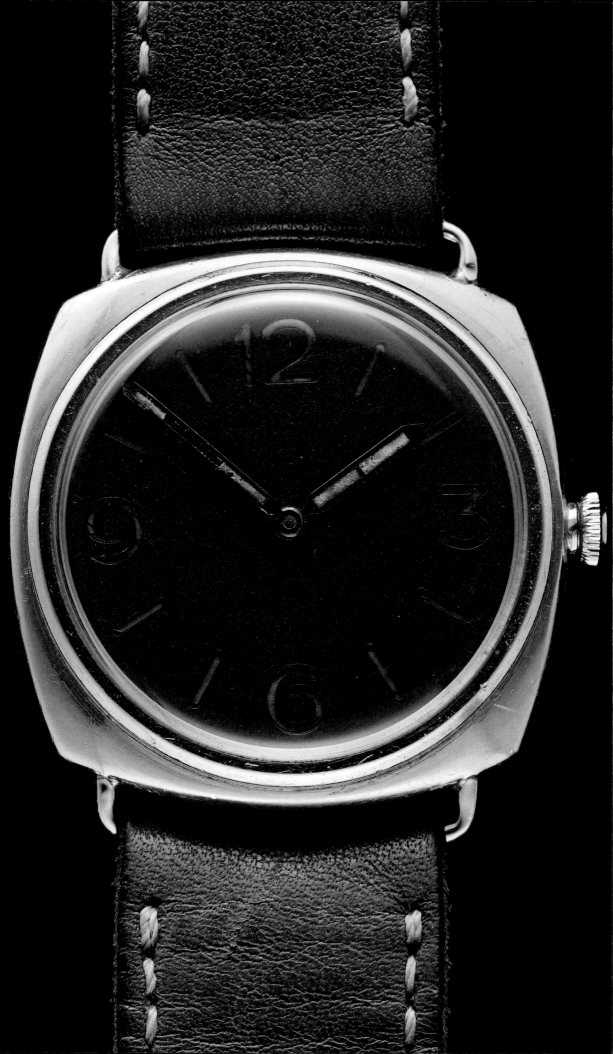

ENG TAY

ARTIST

PANERAI REFERENCE 3646

I've always loved old cars, watches, anything vintage—that's me. I'm not much into the mechanical side. I just love beautiful things—that's why I'm an artist! My younger brother told me about Panerai years ago, and when I would go to Asia for work about once a year, to Hong Kong or Malaysia or Singapore, I'd always go window-shopping to look at the watches. I love shopping for watches, but I didn't buy my first Panerai until 2005. I had the opportunity to buy this Panerai from a friend, and I couldn't pass it up. Not just because of its design but also because of its history—it originally belonged to a Navy officer. It was an important addition to my vintage watch collection. But nothing quite compares to the story of how I acquired my Panerai PAM21.

A friend had just gotten back from an auction and had written about the PAM21, and I had been reading a lot about the watch. I go to Singapore for my yearly trip, and as soon as I get back to New York, over twenty hours on a plane, I turn on my computer and see this guy selling a PAM21, brand-new in the box. In Singapore.

I call him up and he wants crazy money, at least 5 percent above auction prices. But I know this kind of watch doesn't come up for auction all that often, and I tell him I want to buy it. He doesn't know me and I don't know him, so I buy a ticket and fly back to Singapore. We go to a bank, I give him the cash, and then I take the watch and head back to the airport.

So immediately after returning home from Singapore, I got on a plane, flew all the way back to Singapore for one day to pick up a watch, and then came right back. That's passion.

GEORGE BAMFORD

FOUNDER, BAMFORD WATCH DEPARTMENT

**BWD X DRX—ARMY VS NAVY—
"POPEYE" YACHT-MASTER**

Everything you buy has a soul to it. You remember the details: exactly when you bought it, how much you paid for it. You want to think of that item as exclusively yours—unique to you. It's the details, the little things that make you say, "This is special; this is mine." My watch-customization business is about that to an even greater extent.

For me, during my childhood, there was a holy trinity of cartoons: Popeye, Snoopy, and Mickey Mouse. I always liked Popeye the Sailor Man. I loved the whole idea of the spinach-eating muscle man—he was so cool, yet he was just a dude, you know?

So back in 2003 I started talking to my friend and collaborator, Darren Romanelli, thinking, "Could I put Popeye on a watch? How would that work?" I wasn't looking at it from the sales side of things; I just wanted a Rolex Yacht-Master with Popeye on it. I didn't think other people would be obsessed with Popeye like I am, but they are! We launched the watch and it sold out within a week and a half. We're in the third edition of the Popeye watch, and it's a massive collector's piece. We even worked with Hearst, which owns the rights to Popeye, and they created a cartoon of Popeye coming to Bamford Watch Department and me giving the watch to him. I have it in my office—it's such a cool thing.

I always say, when I'm referencing something like an old cartoon series, the big brands have already done it—just think about the Mickey Mouse Rolex. So what I'm doing is really just paying homage to those originals. But I'm doing it with my own twist.

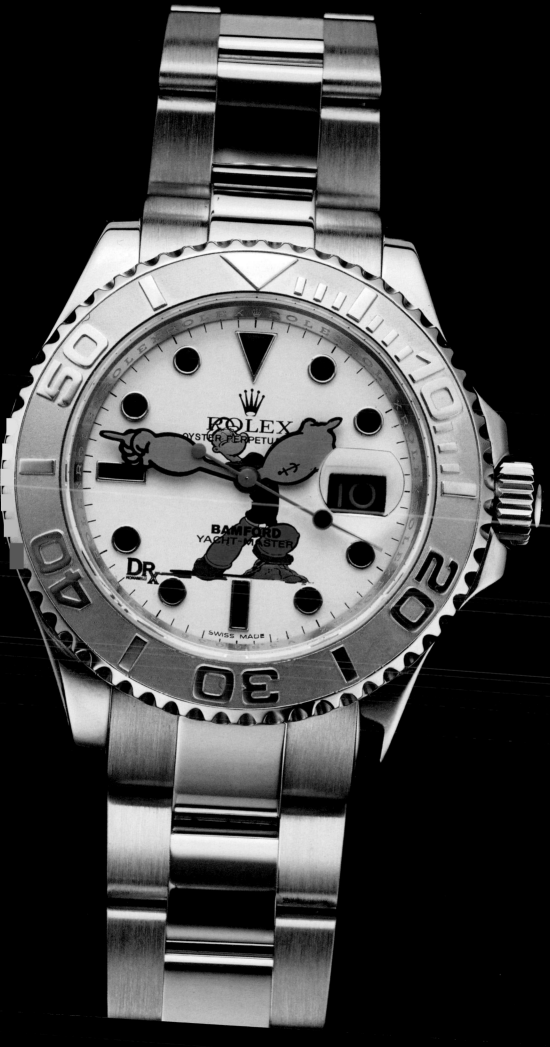

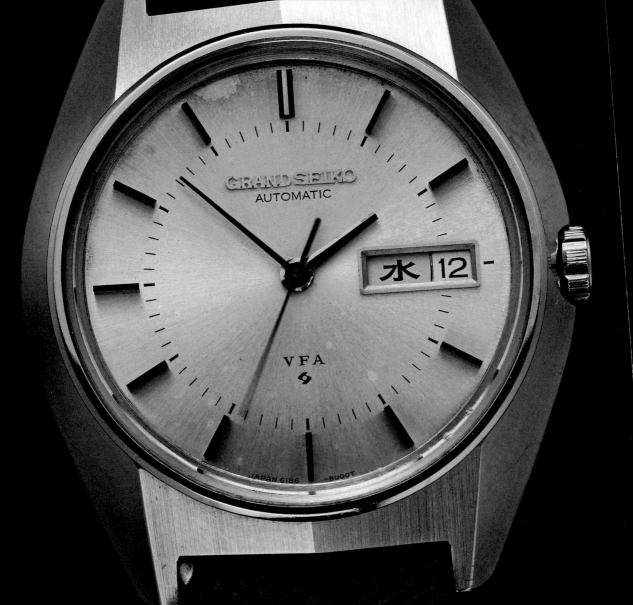

MARK CHO

COFOUNDER, THE ARMOURY & CO-OWNER, DRAKE'S

GRAND SEIKO 61GS VERY FINE ADJUSTED

Part of my business is working with Japanese brands, and I'm interested in the period when Japanese manufacturing came into its own—the fifties and especially the sixties. I love the Japanese attitude, the dedication to trying to be the absolute best you can be, to really push the envelope even given your own constraints.

I got this watch when I was in Tokyo for work, about a three-week trip. Whenever I had downtime, I would go to some of the vintage stores, and I found this watch at one of those shops. It was about ¥800,000, so about $8,000, and I was shocked. I had never seen a Seiko for eight grand, and I thought it was just crazy.

My watch choices are quite instinctive. If there's something I find special about the look of a watch, I'll do some research first, and if it checks out, I'll go for it. Most of the watches in my collection are not necessarily iconic pieces, but oddly enough, some that I bought five or ten years ago have become a lot more important.

So I went home and started to research the Seiko, and I realized how significant the watch was. I loved the look of it, and I loved its history, so I decided to take a punt on it. A week after buying the watch, I was really getting into the brand, so I went to the Seiko museum in northeast Tokyo. And they had the same watch in the museum! It was actually one of the key pieces in Seiko's history, and it made me think, "Okay, I made a reasonable choice."

The Grand Seiko First Series, or the 3180, which predates this one, is really the point when the Japanese had created a watch as good as a Swiss watch. There used to be a chronometer competition in the Neuchâtel Observatory, in Switzerland, and Seiko started entering the competition from the mid-sixties on, submitting various calibers and designs. I believe that the first year they placed 192nd, but over the next five years, developing their skills and designing

better and better calibers, they actually took 4th place. The Swiss stopped the competition the next year, but if you look at the watches from that year and compare the performances, Seiko would have taken the top spot. Actually, they would have taken seven of the top ten spots, with more traditional brands like Omega and Rolex filling out the rest.

Seiko's design language is still in use today: big flanked lugs, lots of planes, quite angular. I find the design distinctive, and I think one day it will be iconic—maybe not today, but ten or twenty years from now, when Seiko's reputation is recognized, it could be a big deal. It's a subtle watch, not really recognizable for what it is, but I like that. It's a lucky watch for me.

Another collector saw my watch and was like, "Holy moly, that's an incredible piece!" So I told him the story and he gave me a formal introduction to the Seiko people. The Japanese way of doing business is very much about relationships, similar to Italian culture. I don't like this current trend toward "We can solve that with an app!" I like to establish a personal relationship. So now the Armoury is the only authorized non-watch retailer Grand Seiko dealer in the United States, maybe even in the world.

"It's a subtle watch, not really recognizable for what it is, but I like that. It's a lucky watch for me."

—MARK CHO

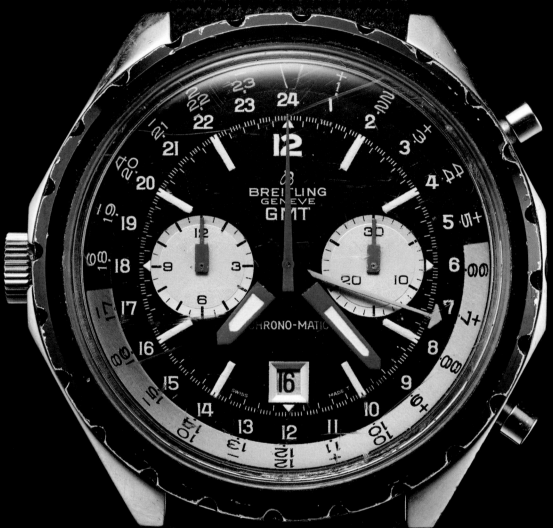

HOLGER THOSS

PHOTOGRAPHER

BREITLING CHRONO-MATIC GMT

This was my dad's watch. He bought it in the late seventies and wore it until about ten years ago, when he gave it to me and said, "I want you to have it. You're going to enjoy it more."

Even though we don't always have the same taste, I love this watch. And I love that he wanted to give me something special. I never would have asked for it. I'm someone who thinks "stuff," to a certain degree, is not important. I have two boys, ages ten and thirteen, and I'm trying to teach them that. Like the Buddhist tradition of creating sand mandalas: you spend all this time and emotional energy to make these very beautiful sand drawings, but you know they are only temporary and will soon be gone. I think there's a real beauty to that concept, and I think of my possessions in that way.

It's also important to cherish the things you have and—this might seem weird to say—to have a relationship with them. You have to honor each object and, at the same time, be ready to let it go.

Ultimately, in the case of my father, it was his act of giving that was meaningful to me, more so than the watch itself.

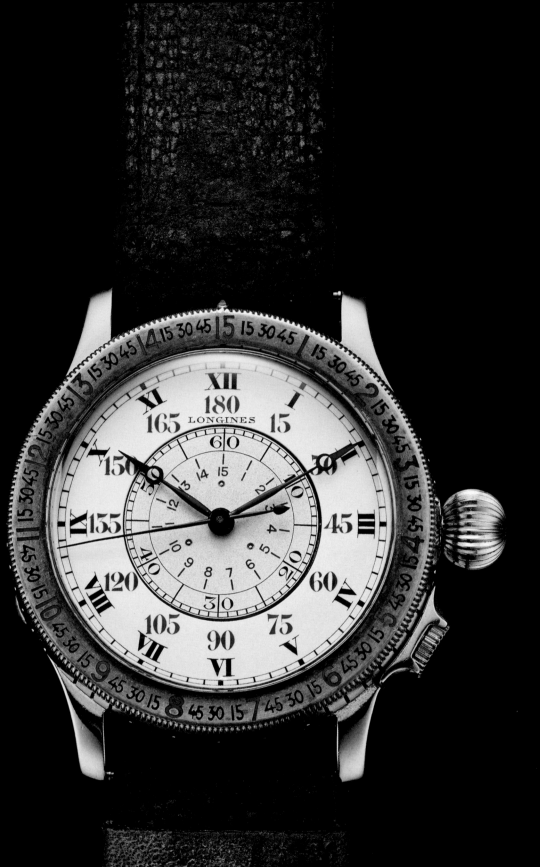

LONGINES LINDBERGH HOUR ANGLE WATCH

In 1927, explorer Charles Lindbergh became the first person to complete a solo transatlantic flight—a 33½-hour journey from New York to Paris. Though Lindbergh relied on dead reckoning and pilotage for his successful flight, he later learned the art of celestial navigation from Navy lieutenant commander Philip Van Horn (P. V. H.) Weems. The result of the two men's collaboration is this watch: the Longines Lindbergh Hour Angle Watch, produced by Longines-Wittnauer and sold in the United States in 1930 and 1931. Lindbergh designed it, and Longines created it because they had timed Lindbergh's historic trip.

The massive 47.5 mm watch helps navigators eliminate one of the key calculations of air navigation by reading off the hour angle of a celestial object at Greenwich Mean Time. In an era when the ability to make such calculations quickly and accurately could mean the difference between life and death, simplifying the process by an entire step was revolutionary. This amazing artifact—which is part of the prestigious Time and Navigation collection at the Smithsonian Institution in Washington, D.C.—is a reminder that for early explorers, tool watches were some of the most important gauges in the cockpit or at the helm.

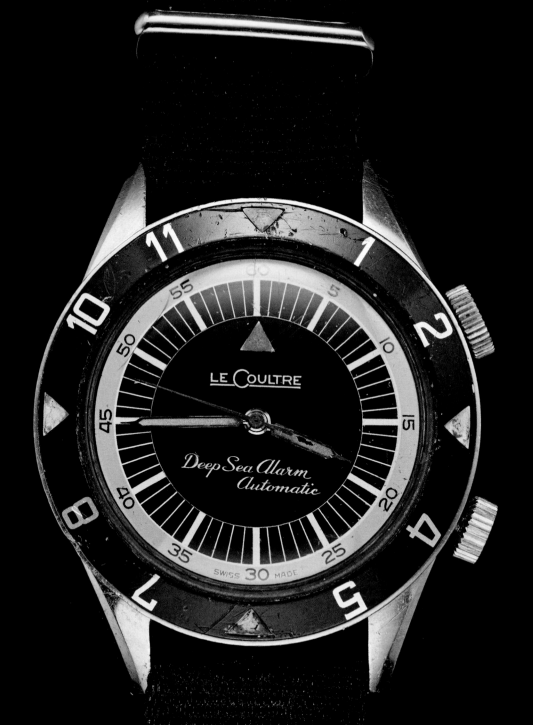

ERIC KU

VINTAGE WATCH DEALER

JAEGER-LECOULTRE
DEEP SEA ALARM

I was always into mechanical things. My dad had a couple of Rolexes when I was growing up, and I was constantly looking at them and playing with them. Every month, we would get a really nice, full-color catalog in the mail from a local jeweler. It was 99 percent jewelry that I had no interest in, but the last two pages would have what at the time were called "pre-owned" watches, always with some vintage pieces included. I couldn't wait for the catalog to come so I could see those watches.

Early in my collecting career, when I was still trying to learn as much as I could about the business, I was offered a Jaeger-LeCoultre Deep Sea Alarm, with box and paper and everything, at a watch show. The guy who was selling it said he thought it was a very special watch because he couldn't find any information on it, but it was similar to a Polaris, it had an alarm, and he really thought I should buy it. My knowledge at that time was limited, and the watch was $4,000 or $5,000, a lot of money. I remember thinking that it was very cool, but I had no idea about the brand, so I passed on it. Two years later, I was asking around about the watch on a European website, and I found out that the price was around $15,000. I realized that I had really screwed the pooch.

So time goes by and I keep learning more about the watch. I always liked its aesthetic—the "Deep Sea Alarm" script on the dial— the whole thing just oozes fifties. Then, two years ago, it shows up on a vintage watches forum on Facebook with the caption, "Hey, I just found this watch at Goodwill for $5.99. I think it's really rare—what do you guys think about this?"

Everybody was posting that it was some sort of BS or April Fool's Day joke, but I messaged the guy and told him I was interested in buying it. We ended up striking a deal; I flew him out from Arizona to

"Watches are very personal things— expressions of who you are."

—ERIC KU

San Francisco, we spent the day together and I put him up in a hotel, and he sold me the watch. For $35,000.

In retrospect, I feel like I paid . . . let's say, maximum, maximum collector price. But as far as I'm concerned, this is a unique watch because the history is so fascinating. The guy bought it at a Goodwill in Phoenix, I bought it from him, it was written up on Hodinkee, and from there the story just blew up. It was front-page news on CNN's website, then picked up by local and national news channels and a random morning show. It was unbelievable.

Watches are very personal things—expressions of who you are. And what you're willing to pay all comes down to perception of value. The Deep Sea Alarm was probably $100 in the fifties or sixties, which was a tidy sum of money but not completely outrageous, and the fact that something like that could be worth fifty or a hundred times more today is kind of crazy. But this watch sums that up completely. Somebody loved it, then it got lost in the shuffle. As soon as I saw it I just knew it was a watch I had to buy, even if I paid a premium for it, which I did. So regarding the perception of value: somebody literally perceived the value of this watch to be $5.99.

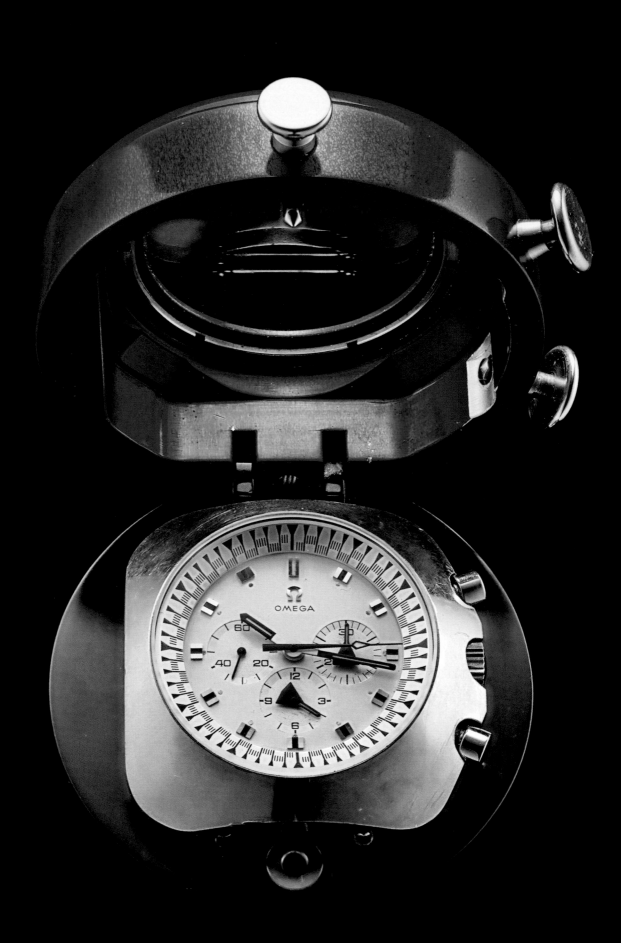

OMEGA SPEEDMASTER
ALASKA PROJECT PROTOTYPE

JAMES H. RAGAN

FORMER AEROSPACE ENGINEER, NASA

OMEGA SPEEDMASTER MOONWATCHES

I didn't get to NASA until the start of the Gemini days, and watches were just one of many, many pieces I tested and procured as part of the flight equipment. It was crucial for each astronaut to have a flight watch to time an event or experiment. Mission control did the critical timing, but if they lost communication with the astronauts—like when they were out on the lunar surface—the astronauts needed watches as a backup. Otherwise, they wouldn't know how much time was left on their suits before they ran out of oxygen.

As a government entity, you can't just go out and buy pieces of hardware and look at them—you have to do a competitive government procurement, unless there is justification to use a sole source.

We had four companies send us proposals. One of them was rejected outright because we had specified wrist-worn and it wasn't—it was more like an Olympic timer. So from each of the other three companies, we bought three watches. I needed one set to give to the astronauts, one set for testing, and one set in case we screwed up somewhere and damaged the watch.

When I was through with all the testing, the only watch that successfully passed all the tests was the Omega. Now, I didn't know at the time that a pair of the watches that flew in the earlier Mercury days had been Omega Chronographs, but those had been bought personally by two of the astronauts, Wally Schirra and Gordo Cooper. It was sheer coincidence that it was the same brand.

NASA kept using Speedmasters all through every moon landing, through Skylab days and Apollo-Soyuz. Exactly the same watch, except for some enhancements—including an asymmetrical case and, most important, protection for the crown and pusher so they wouldn't bend and therefore need to be replaced each time. These

few adjustments made what we know today as the Speedmaster Professional Moonwatches. Those pushers never bent again.

The best example of when the Omega Speedmaster Professional paid off for NASA was during the Apollo 13 mission, when all power was lost on the Command Module. The only things the astronauts had to time the critical burns to bring the Apollo 13 safely back to earth were their Omega Speedmasters. Most critical was the last burn, which had to be a precise 14 seconds. The commander's chronograph was used to time the burn. The watch was exact, and the rest is history.

I purchased a total of ninety-six Omegas from the day we started buying them to the end of Apollo. Some of them burned up in the fire at Cape Canaveral, we lost some in airplane crashes, some were stolen, one or two ended up in the Banana River because the guys were water-skiing with them. But at the end, I took every one that had any history to it at all and pulled them off to the side. The best I recall it was about forty-four items in all. I said, "Okay, these need to go to the Smithsonian, if they want them."

And at first they didn't want them! I said, "You guys are crazy— I've got all the watches that went around the moon. I've got some from the Gemini days." I sent them a list and they reconsidered my offer. I'm glad I made the effort, because I don't think they would have taken them otherwise.

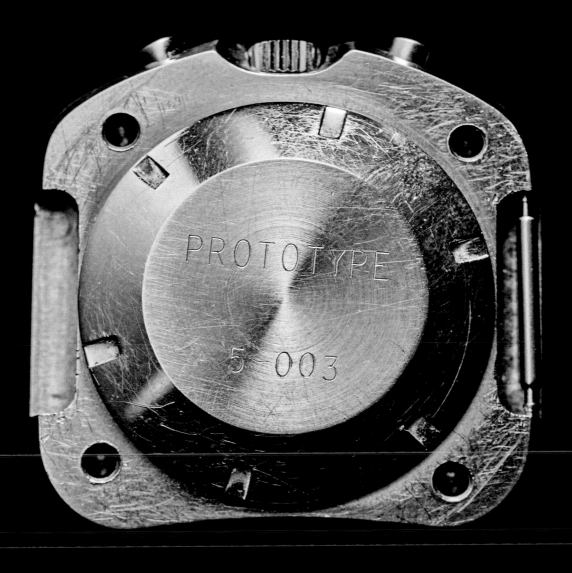

OMEGA SPEEDMASTER ALASKA PROJECT PROTOTYPE (BACK)

James Ragan was also the mind behind this futuristic watch, an attempt to create the perfect timepiece for outer space, which was code-named "Alaska" to throw off any attempt at industrial espionage. The watch aimed for triple protection against space's harsh conditions, utilizing polished titanium, which is resistant to extreme temperatures; a specially reworked movement that featured pioneering metal alloys and lubrication to give it a much stronger resistance to the extreme temperatures encountered on the lunar surface; a silver-white dial so as to absorb no heat from the sun's unfiltered rays; and the distinctive red anodized aluminum outer case, which rendered the Moonwatch Alaska especially "space proof."

The Alaska watch exists as a historical oddity, though a significant one, since the Apollo missions for which it was planned were canceled in the seventies, and the watch never got the chance to prove itself in the environment for which it was created.

FROM THE
OMEGA ARCHIVES

Omega was the one archive that actually came to me—no secret locations or security checks or retinal scans needed. My friend Petros at Omega simply phoned and asked me what I wanted to see, and the next time business brought him through New York, he arrived with an untold fortune of priceless vintage Omegas on his person. When you have the incredible history of being the official watch of NASA's early space programs, it makes sense that you'd want to tell that story far and wide.

We got the unbelievable chance to photograph a second-generation Omega Speedmaster reference CK2998: the personal watch of Walter "Wally" Schirra—one of the "Original Seven" astronauts of the Mercury program—which he wore during the Mercury-Atlas 8 (Sigma 7) mission, making it the first watch in space. This was before NASA had an official working relationship with any watchmaker; both Schirra and Leroy Gordon "Gordo" Cooper personally bought Speedies as their flight watches.

We also had a unique opportunity to photograph John F. Kennedy's inaugural watch, which Omega brought out of its archives to be included in this book.

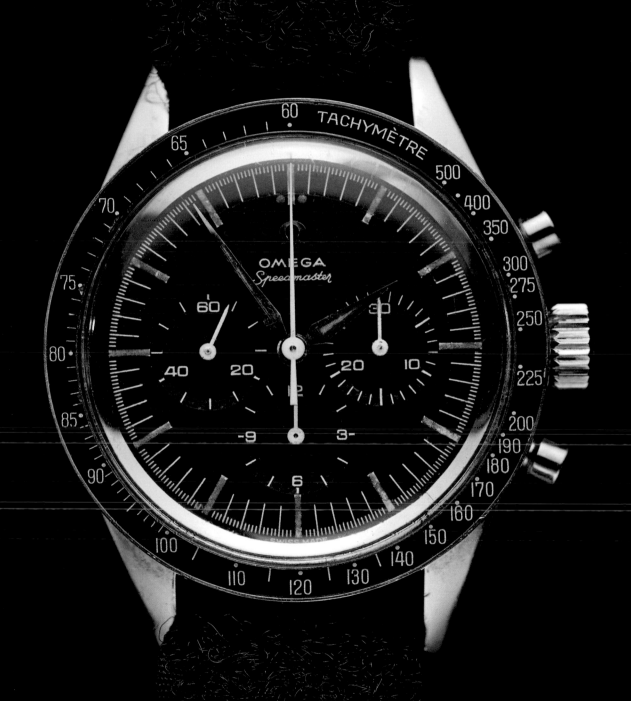

WALLY SCHIRRA'S OMEGA
SPEEDMASTER REFERENCE CK2998

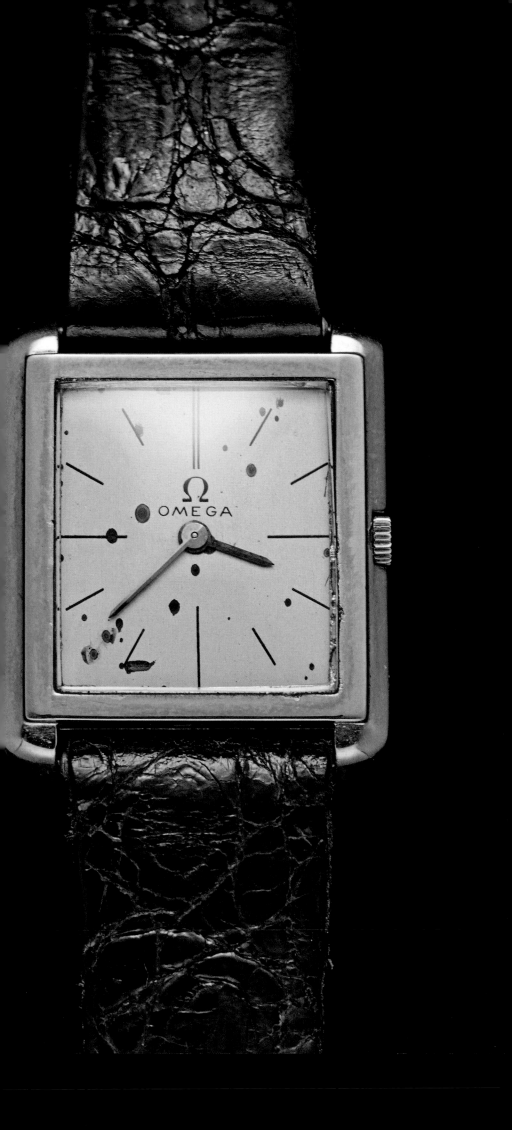

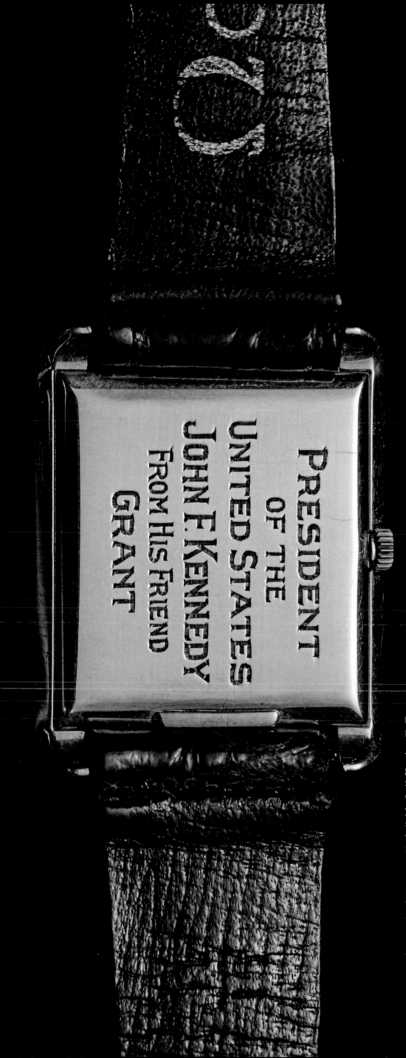

PRESIDENT JOHN F. KENNEDY'S INAUGURATION OMEGA

The inscription on this ultrathin yellow-gold Omega—"President of the United States John F. Kennedy From His Friend Grant"—seems unassuming, until you realize that Kennedy's friend and supporter Grant Stockdale had gifted the hand-wound tank watch to Kennedy in 1960, when he was still a senator from Massachusetts. The following year, when Kennedy was sworn in as the thirty-fifth president of the United States, he was wearing this very timepiece. Kennedy appointed Stockdale as ambassador to Ireland, writing to him in 1962, "Ireland must be lovely at this time of year," and finishing with, "I thought you might like to know that I am now wearing the Stockdale watch. Again."

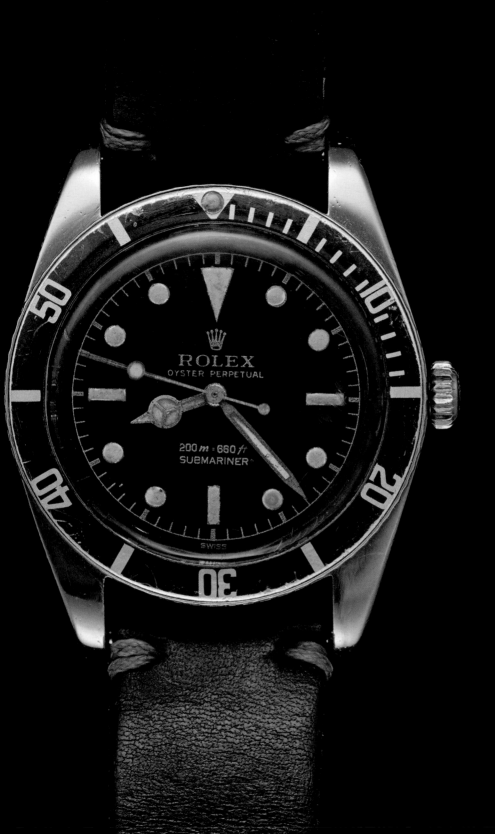

ALESSANDRO SQUARZI

FASHION ENTREPRENEUR

**1958 ROLEX SUBMARINER
REFERENCE 5508**

My father gave me this watch when I was eighteen. I got one watch; my older brother got another. I'm a collector of vintage Rolex, the sport models in particular, and this was the first one I owned. I remember my father wearing it when I was a boy, but it still looks so modern—the Submariner is one of the most successful models of all time. I wouldn't sell it for any amount of money; it's priceless.

GABRIEL VACHETTE

FOUNDER, *LES RHABILLEURS*

UNIVERSAL GENÈVE COMPAX

This watch belonged to my grandfather Josef. He gave it to my father about twenty years ago. My father loves collecting things—art and sculpture especially. Whatever he gets into, he starts collecting. But he didn't know anything about watches at the time.

The watch was broken when he received it, so he brought it to the local watchmaker to be repaired, and the guy said, "This is going to cost you a lot of money—like a thousand francs." My father was taken aback and asked him why it was so pricey. The man said, "Do you know what your father gave you?"

He opened the back case of this very tiny watch to reveal its complicated chronograph movement; it's quite amazing. At that moment, my father fell in love with watches, at fifty years old.

I was maybe fifteen years old at the time and saw my father getting into the hobby, building up a collection. I knew a bit about watches—I wanted an Omega Seamaster because of James Bond—but I really fell in love with watches through the stories my father told me about the watches he was buying. When I was twenty-five and working in Paris, I decided to create my own watch blog, one that is more lifestyle-focused than about watchmaking. And that's how *Les Rhabilleurs* started.

I was always close with my father, but now every time he calls me, it's about a watch. Like, "Hi, how are you, I found this amazing watch, blah blah blah, okay, bye!"

What my father loves best is the buying and selling, but we'll never get rid of this watch. It will stay in the family forever.

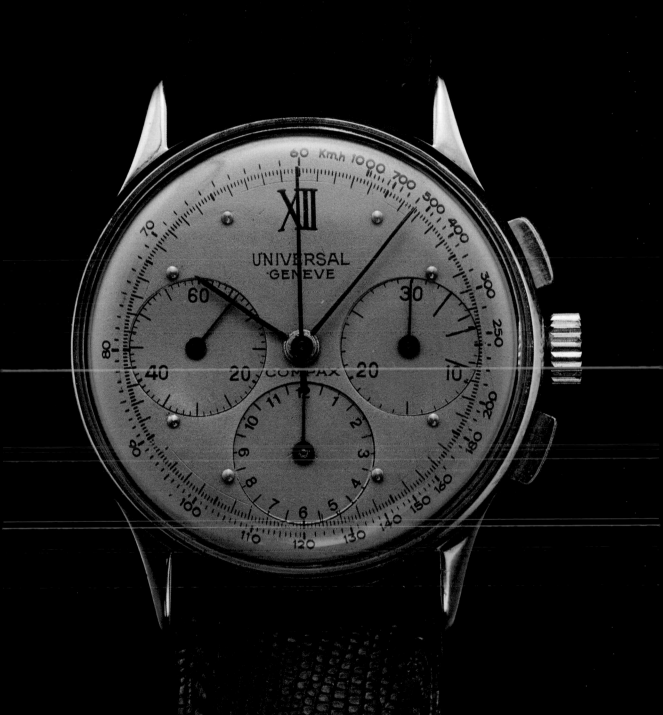

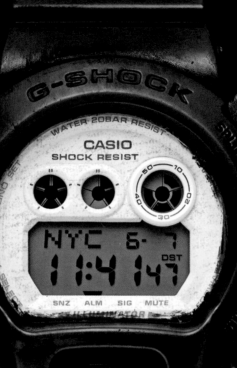

KENTA WATANABE

COFOUNDER, BUAISOU INDIGO STUDIO

**INDIGO-DYED
CASIO G-SHOCK**

I'm an indigo dyer and farmer. My hands and arms are immersed in an indigo dye every day. This G-Shock was white originally. My friend who was doing a Casio promotion gave it to me and was curious to see what would happen if it was repeatedly submerged in the dye. It's a strong watch, and waterproof. After two years, it had turned this amazing indigo color. Much better than the original!

Several G-Shock owners noticed my watch and sent me their watches to be dyed, so we made a few customer examples, too.

As I explained to them, if you wash the watch in enough clear water, the dye will come out of the plastic and it will be white again.

HAMILTON POWELL

FOUNDER & CEO, CROWN & CALIBER

ABERCROMBIE & FITCH SEAFARER

This Seafarer is unlike most any other in existence, in that it has a running second hand. No other Seafarer I've ever seen has that. It's debatable why it's there. One opinion is that a past owner commissioned a watchmaker to add that feature so he could see if the watch was actually wound, because otherwise you couldn't know immediately. The other thought is that perhaps it was a prototype of some kind.

These were made by Heuer for Abercrombie & Fitch, a company that, before it became known as a shirtless male model fashion brand, was a really cool adventure outfitter. If you were going to climb Everest, or spend a month in the Rockies, you'd go to Abercrombie & Fitch to be outfitted. It was legit.

But the thing I like most about this watch is that it tells the story of two different kinds of guys. It was originally made to be an outdoorsman's watch—it measures the tides for boating or fishing; all the original ads featured a guy fly-fishing or doing some other outdoor activity. But it's also for a guy who wants to wear a beautiful watch, who wants to come inside, take his waders off, and put on a tux. It was meant to be worn that way, too—it has a beautiful case, it looks great, it fits nicely under a cuff.

My first job out of college was as a hunting guide. Now I'm the CEO of a company that's in the luxury watch space. I play both of those roles really well, but I don't like being in either world too long because I start to yearn for the other. I perform this balancing act, and to me, this watch is perfect for that.

I also like that it's a manual-winding watch. I believe we're alive for a brief period of time; whether it's fifty years or a hundred, in the scheme of things, that's a short blip. And it's up to us to use that

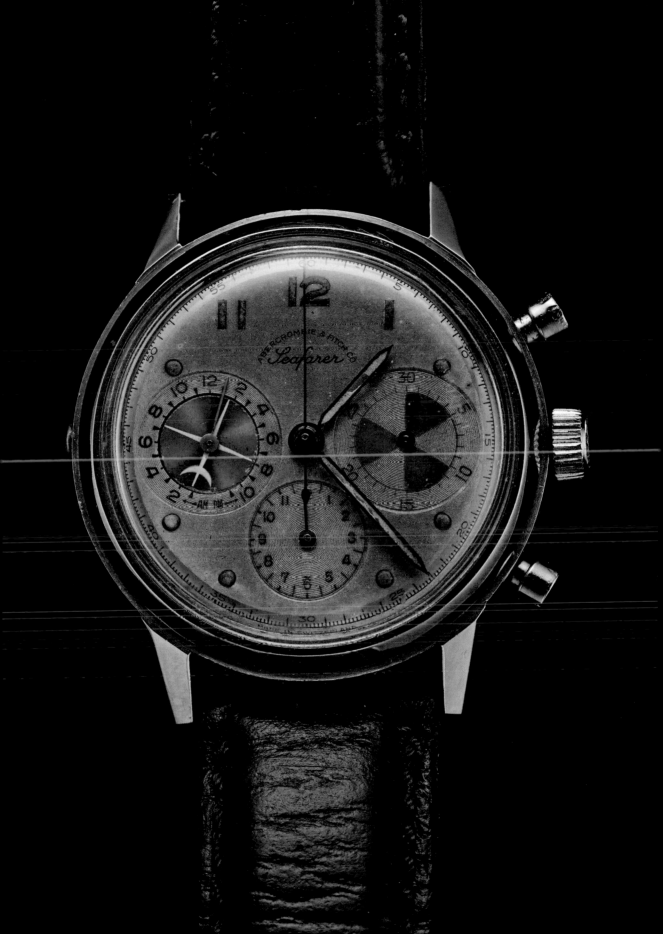

time intentionally. Running a company is a fast-paced life, and being at home, with three kids, is an even faster one. So taking a moment to wind my watch means giving myself twenty seconds of the day to create a sense of purpose as to how I'm going to use my time—to ask myself, Am I going to live today with intention? It forces you to reflect, because during that tiny window you are literally giving yourself the time.

"Taking a moment to wind my watch means giving myself twenty seconds of the day to create a sense of purpose as to how I'm going to use my time—to ask myself, Am I going to live today with intention?"

—HAMILTON POWELL

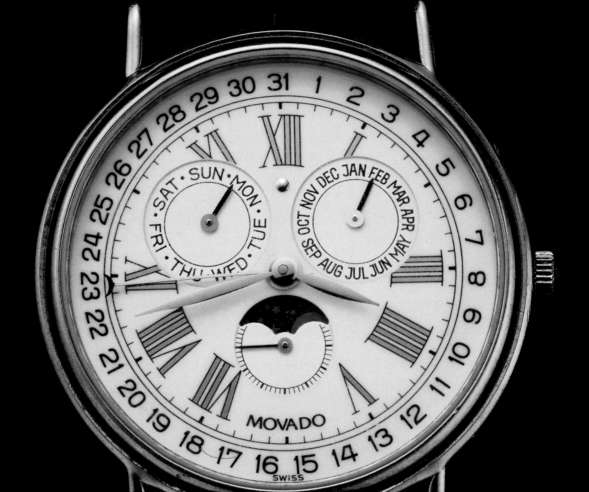

JOSH CONDON

WRITER, EDITOR & AUTHOR

MOVADO MOON PHASE

Watches aren't really a big deal in my family, but the idea of heirlooms is. Over the years, I've been handed down a number of interesting things from grandparents and great-grandparents and relatives from various branches of the family tree—my grandfather's Givenchy tuxedo, an old Montblanc fountain pen, the odd pair of cuff links, a beautiful navy wool peacoat that must weigh ten pounds and supposedly dates back to World War I. My dad loves passing things on to his kids, even if it's just a shirt of his that you once said you liked. There's never any ceremony, and not much of a story; one day he'll simply hand you something like an old cribbage board and say something like, "Isn't this cool? This was your grandfather's. You should have it."

My dad has a few watches, some of them expensive, but he's not an enthusiast. A few years back when I was visiting him in Massachusetts, where I grew up, he kept going on about this delicate little Movado he'd bought on eBay. It's a tiny little thing, maybe 29mm—I'm pretty sure it's a woman's watch, actually—with subdials for the day and date, and another for the second hand, which also incorporates a moon phase. It's gold-plated and quartz-powered, and a collector wouldn't look at it twice, but my dad just fell in love with it.

I'd started writing about watches for magazines and had been really reading up on the subject, and as happens to a lot of budding enthusiasts, knowing a little made me a bit snobbish. I always liked the way that Movado looked, but because it didn't mean anything in the collector world, I didn't think it had any value. But two years ago, on my thirty-sixth birthday, my dad gave me his watch—not the one off his wrist, but the exact same model, which he had been searching for since he bought his own. He spent two years tracking down three more, one each for me and my two younger brothers,

"The watch reminds me of my family every time I look at it, and there's not another watch in the world at any price that can pull off that trick."

—JOSH CONDON

having them cleaned and serviced and replacing the bands. He gifted them to each of us on special occasions—a birthday, starting a new job, buying a house. So all the men in my family now wear the same watch.

My family all lives in Massachusetts, and I've lived apart from them, in California and Michigan and New York, for over half my life now. And right at the time when I was trying to figure out what brand and model of watch would define me, my dad made the choice for me—a nonmechanical timepiece from what was at the time a middling brand, worth a couple hundred bucks on eBay. I basically haven't taken it off since. It reminds me of my family every time I look at it, and there's not another watch in the world at any price that can pull off that trick.

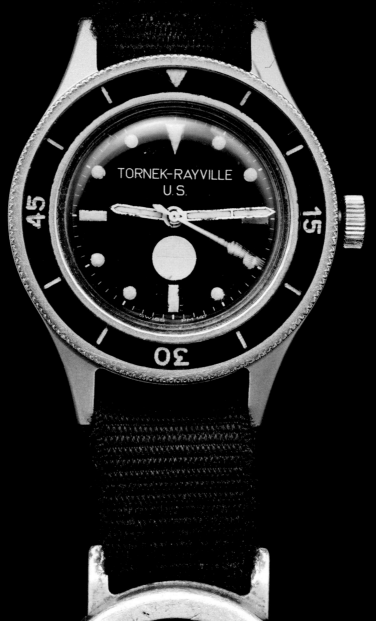
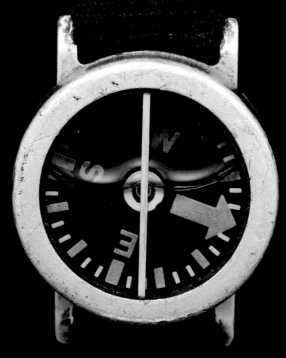

TORNEK-RAYVILLE TR-900

This dive watch is an excellent example of the type of military-specification watches many collectors go nuts for—and is itself one of the most rare and sought-after specimens.

The original design is a Blancpain Fifty Fathoms from the early 1960s, a model originally created for French navy combat divers in the early 1950s and considered the original dive watch, predating even the Rolex Submariner. Due to a tightly enforced "buy American" policy at the time, the American government couldn't purchase these technologically advanced timepieces directly from the Swiss company Blancpain. American businessman Allen V. Tornek instead imported, rebranded, and resold the Fifty Fathoms through his U.S.-based company, Rayville.

Around a thousand Tornek-Rayville models were produced, and nearly all of them were later destroyed by the U.S. Navy due to rules about atomic waste disposal (the watches' dials used radium paint for luminosity), making these models exceedingly rare. This particular watch was issued by the U.S. Marine Corps in 1966 to Sergeant Maurice Jacques, who wore it through six years of combat in Vietnam with Force Recon and through to his retirement as sergeant major of the 5th Marine Regiment. Sergeant Jacques served his country for thirty years and was awarded two Bronze Stars and a Purple Heart.

GEOFFREY HESS

CEO, ANALOG/SHIFT

**ROLEX EAGLE BEAK TROPICAL
SUBMARINER REFERENCE 5512**

I don't have a family history of being handed down watches of any significance; I'm just a regular guy who liked to play with this specific kind of toy. But for me, without question, it's the people behind the watches that fuel this fire; I don't think there's a major city on earth that doesn't have a bed for me to sleep in because of the people I've met over the years through this hobby. I even met my wife because of it.

My great love is vintage Rolex, and a couple of times a year I go to Europe to attend gatherings of collectors from all over the world. There's something very meaningful to me about being the guy who gets on a plane with a little messenger bag, carrying his entire life's passion—and, to some degree, identity—all the way to Europe to meet with this special group of guys. We embrace almost like brothers. And then, two days later, I get back on the plane and come home.

It's a rare hobby that keeps a man up until dawn poring over the most minute details. I'll try to explain it with this Rolex Submariner. One thing we hear over and over again in the vintage watch world is the expression "it ticks all the boxes." What makes this watch special is a confluence of factors. The first box that's ticked is the dial: it's "tropical," and people love the idea that, over time, a dial can go from being black in color to this beautiful bronze, caramel, creamy brown tropical hue. Box number two is the notion that everything matches; you can see that the luminescence on the dial and the hands and the pearl on the bezel match perfectly, so you know this was all born together. Box number three, perhaps the most interesting, has to do with the shape of the crown guards, known as an "eagle beak" because when you look at one head-on, it looks like the open mouth of an eagle. This was a transitional

form of case, and these crown guards only appeared in 1959, so, box four—it's rare.

People make fun of the vintage Rolex world to a degree, because those of us who love these watches will study every detail. But we're celebrating something, looking back to an older era; if we weren't, we'd all buy modern watches because they tell time better, they're more durable and technologically proficient. But to some degree, the world of vintage Rolex is a science; we collectors always have a loupe, and we're examining the colors, the serifs on the fonts, the way the Rolex coronet is printed. It's a grown-man science. I'm forty-seven years old, and I never truly understood what the word *passion* meant until I discovered my love for timepieces.

"It's a rare hobby that keeps a man up until dawn poring over the most minute details."

—GEOFFREY HESS

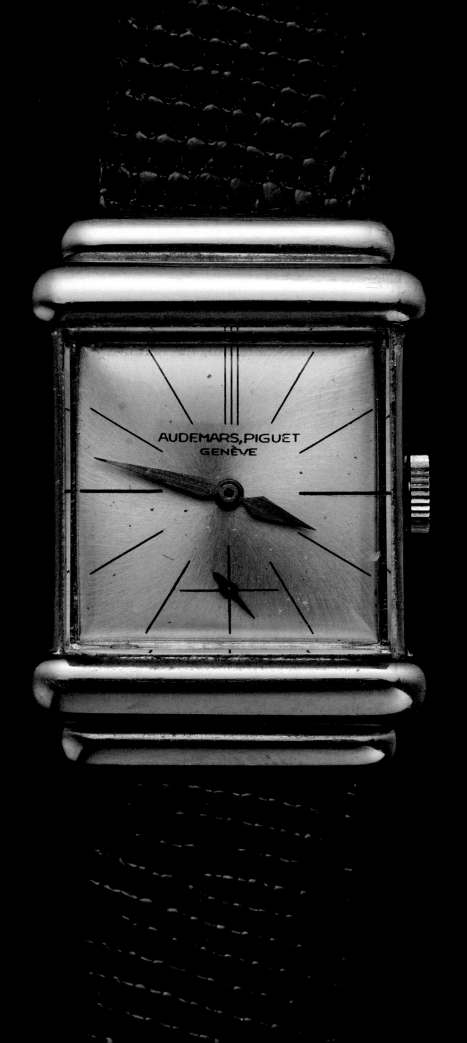

MICHAEL FRIEDMAN

HISTORIAN, AUDEMARS PIGUET

1938 AUDEMARS PIGUET

In 2003, when I was the department head of Christie's Watches in New York City, this watch was included in what would be my last auction. One collector/dealer I spoke with said he had an interesting Audemars Piguet he was thinking of putting into the sale, and when I saw it, I thought, "This is great." I was in touch with the Audemars museum director, Martin Wehrli, who researched the piece in the archives and learned that the watch had been exhibited at the 1939 World's Fair in New York, a fact that I included in the catalog notes.

My dad read the catalog and saw that note. A New Yorker and a baby boomer who was interested in the crossover between culture and science, he had always loved the World's Fair—that cross section of technology and futurism and all these things in one place at a time before Comic Con, before technology festivals and industry trade shows. So he asked, "Is this something we should consider for our collection?" And I replied, "Absolutely it is."

My introduction to this field wasn't through mechanical horology; it was through cultural studies—how time itself could be broken down differently depending on the time period, on the particular culture, on the astronomical events that have been occurring for billions of years and will continue to occur for billions of years. The entire history of science and technology, of human development, is anchored to time measurement.

This understanding came in part from my dad. He had a scientific mind—he was a science teacher who went into finance to better provide for his family, even though he always felt like an outsider in that world, even though his passion was always science and teaching and sharing. I remember he kept binoculars around the house, and he'd encourage my brothers and me to just look up into the trees, to

"This piece epitomizes my father's and my mutual love for the crossover between culture, technology, and design."

—MICHAEL FRIEDMAN

explore and think outside of the immediacy of our own sphere. Even watching television, he'd sit there and tell us how a TV operates, what makes it work. And he was committed to making sure we damn well did what we wanted to do in life—that we had the opportunities to follow our own passions, because he hadn't been able to follow his.

This watch is emotional for me in that regard—its being in my last auction, during a pivotal shift in my career, and a moment shared with my father that I'll treasure forever. This piece epitomizes our mutual love for that crossover between culture, technology, and design.

TOM SACHS

SCULPTOR

"NEW BEDFORD"
(CUSTOMIZED CASIO G-SHOCK DW-5600)

As a kid I always wanted a G-Shock, but they were too expensive. In the digital watch realm, the G-Shock was the ultimate status symbol. So I got a cheaper digital watch and made my own version by hot-gluing a metal cage around it.

There's something incredibly well-crafted about the G-Shock, and I think it's no coincidence that the Japanese produced it. In Japan, watches aren't traditionally status symbols; gifting someone a watch is considered to be a bad-luck gesture—you don't give someone an object that tells them how much time they have left to live. So what the Japanese did with the G-Shock, and with Casios in general, was to eliminate the concept of status and create a covetable watch at a much lower price point.

The story behind the New Bedford is that I wanted to make a blue-collar version of a double-wrap watch like the Hermès Cape Cod. The name of the watch comes from the idea that the people who work on Cape Cod actually live in New Bedford, Massachusetts. I sold a short run of these—maybe a dozen.

People wear watches for their associated value. You wear an Omega Speedmaster and you're Neil Armstrong. Or you wear what-ever watch James Bond wears, or Sir Edmund Hillary wore, and you become that person—even if you work in an office, at least your watch is the same as that hero's. That always seemed phony to me, because I'd rather be an astronaut or a spy or a mountain climber, with all the risks that go along with the rewards of those careers. Having done a lot of extreme things, I needed a watch for those situations, especially so that I would have the time without getting sucked into the black hole of my iPhone. An armored digital watch works better in every possible scenario with the exception of nuclear

detonation, when the magnetic pulse would make all electrical things stop. But I think if that happens, you've got bigger problems.

There's a sense of pride that I've been wearing the same watch for the past twenty years. I've gone through four of them, but it's always the Casio G-Shock DW-5600, and I have a habit of personally engraving each one the day I get it. There have been many versions of the G-Shock in the past twenty years, but this is the best. It's got an alarm, and it's still the best shape.

My dad has a fancy Swiss watch that he says he's keeping to pass on as an heirloom. He quotes the manufacturer's ad: "You never actually own a Patek Philippe. You merely take care of it for the next generation." We laugh about how the cliché advertising motto has come true. I'm sure that watch might hold some meaning, but I like the idea of something that costs $40 that you own, versus something that costs $4,000 that owns you.

"There's a sense of pride that I've been wearing the same watch for the past twenty years."

—TOM SACHS

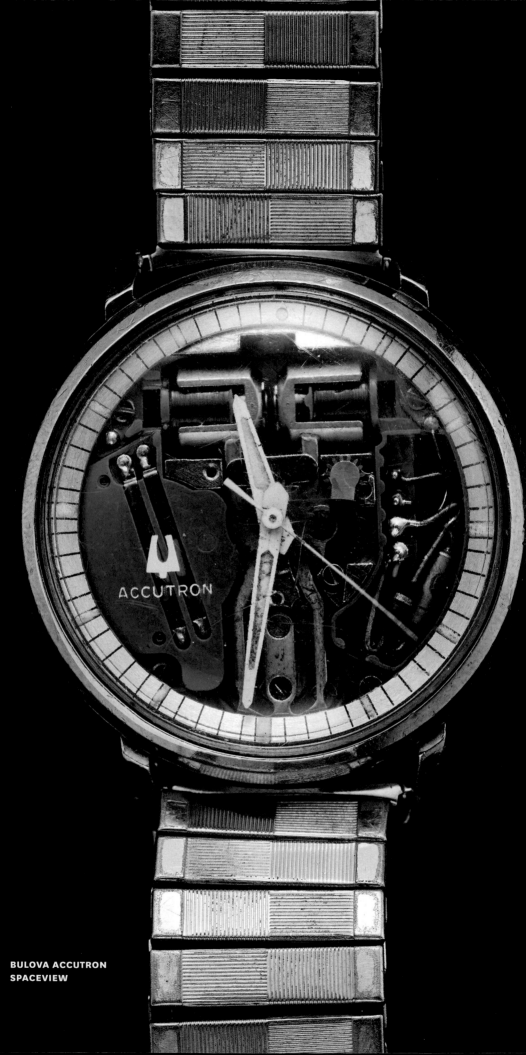

BULOVA ACCUTRON
SPACEVIEW

BRE PETTIS

FOUNDER, BRE & CO.

BULOVA ACCUTRON
SPACEVIEW & ORIGAMI WATCH

My favorite activity growing up was making stone circles like Stonehenge, basically trying to replicate these superaccurate megalithic timepieces that date back five thousand years and still work. They have all these astrological and astronomical alignments, so on certain days when you stand in a particular place and the sun rises over one particular stone, it's poetic, and it makes you realize that we only get so many of these moments in a lifetime.

What's interesting when you consider stone circles and watches is that stone circles are about connecting time to a specific location; when the sun is at its highest *right here*, at Stonehenge, it's noon— but a hundred miles away, the time would be slightly different. Watches, however, represent a worldwide contract with time—if it's 11:38 a.m. in any given place, then everywhere else in the world it's thirty-eight minutes past some hour, depending on this time zone construct we've all agreed to. It's kind of crazy, when you think about it, like a minor miracle.

My first watch was this Bulova Accutron Spaceview. My grandfather gave it to my father, and my dad gave it to me when I graduated from high school. The watch was a transition point between mechanical movements and the quartz revolution, and it's a totally different approach—a 300 Hz tuning fork pushes a tiny gear, smaller than a quarter of an inch, with three hundred notches in it. That one gear required a new design of machine just to produce it; Bulova was the first to figure out how to make a tuning fork work as a gear-driving mechanism in a watch. The watch has a cutting-edge transistor, and a capacitor, and a resistor, and that's it. It's absurdly accurate, to two seconds a day, and all of this was built in 1960, without computers, before integrated circuits. They used the technology on the Apollo mission.

When I decided to create my own watch, the Origami Watch, my goal was for it to be as innovative as the Accutron was in 1960 in coming up with a way to track time. But the Origami Watch is about more than that: I wanted to create something that would make people feel as if they're winning an Olympic medal when they receive it. You can't buy this watch for yourself—part of the buying process is that you have to dedicate it to somebody and say why you think they're great and what values they have that you admire, and there's a spot to inscribe something to them. There's stealth value to it, too: a quarter-ounce American Eagle gold coin integrated into the back worth seven or eight hundred bucks, depending on the value of gold, that touches the skin. In an emergency, you can turn the watch over and pop out the coin.

My goal in life is to encourage deeper friendships in the world. I did a lot of research trying to figure out what people could give to encourage those friendships, and watches have the best stories. I also like to make stuff. This obsessive watchmaking has become the amalgamation of those two things.

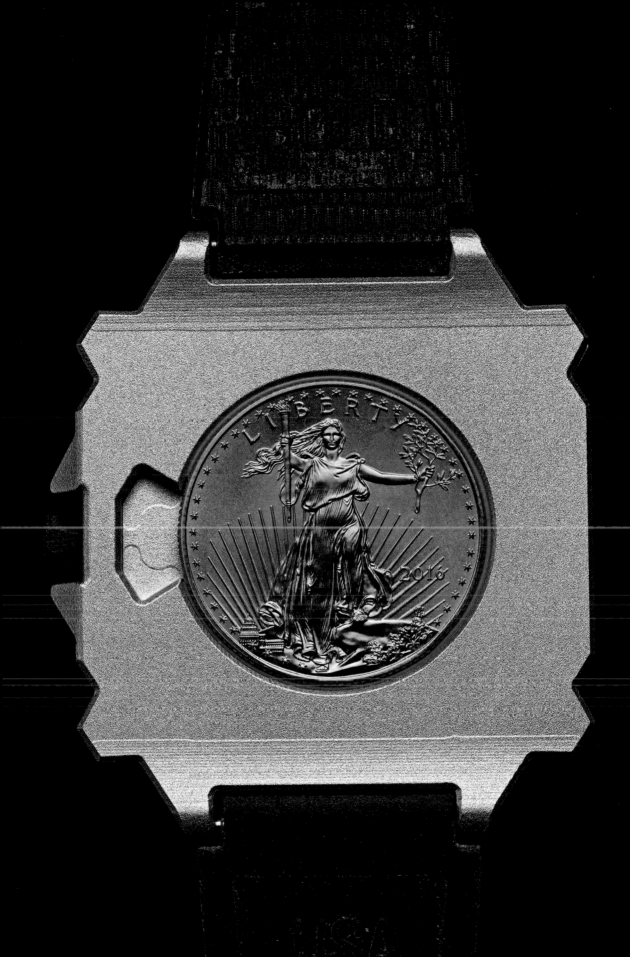

ORIGAMI WATCH
(BACK)

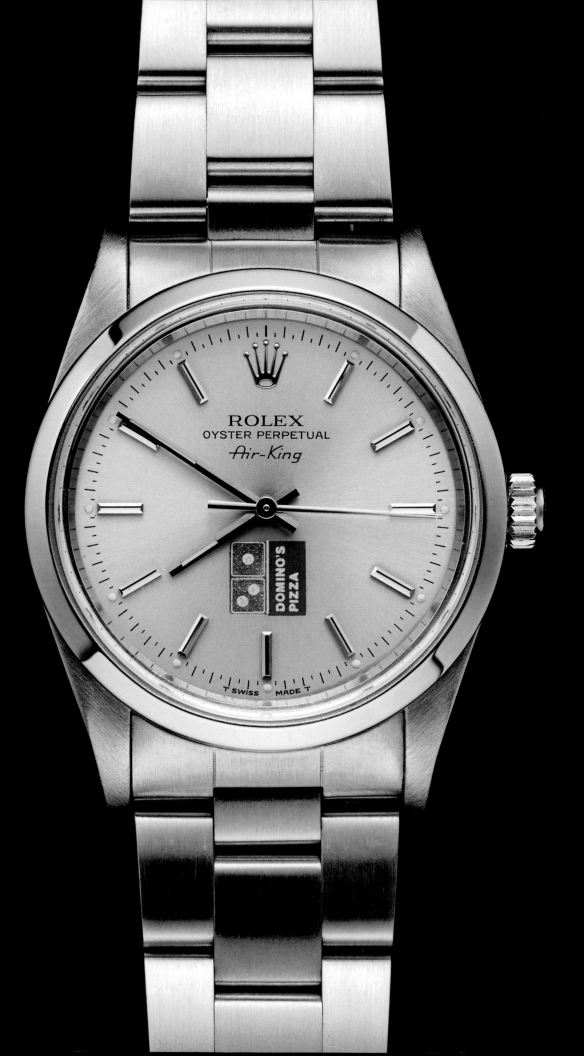

*You are now a part of select group
that wears a Domino's Pizza Rolex Oyster watch
as a banner of achievement.
The Rolex Oyster is an instrument of supreme quality,
one of the world's most sought-after fine watches.
It is a symbol of prestige that you can wear proudly
for reaching $20,000 in weekly sales
for the first time in your store.*

Congratulations!

Thomas S. Monaghan

DOMINO'S ROLEX AIR-KING

Among collectors, this is what's famously known as the "Domino's Rolex"—for obvious reasons. The story is that Domino's, back in the seventies or eighties, started giving these cobranded Air-Kings out to franchise owners for hitting sales numbers. This one is from the 1990s, the last years they had the color Domino's logo on the face. For a while, after Rolex became stricter about cobranding watches, they started soldering the pizza box onto the bracelet; now it's just an engraved Domino's logo on the back. But those aren't as fun as this one, the ultimate high-low mash-up of a college dorm favorite and one of the most recognizable luxury brands on the planet.

STEPHEN LEWIS

PHOTOGRAPHER

PAPER CUTOUT OF A HEWLETT-PACKARD CALCULATOR WATCH

In fifth grade, I noticed some flashy gold Rolexes worn by the parents of a girl that I liked, and I got the watch bug; I was intrigued. My parents were intellectuals and frowned on any kind of ostentatious display, so I kept my interest to myself. I used to cut out my favorite watches from the pages of magazines, tape them around my wrist, and wear them in the privacy of my room. With some imagination, I could have any watch I wanted—as long as I could find a picture of it.

Fast-forward to the 1970s, watching *Live and Let Die* in the theater with my friend Eric. Roger Moore's James Bond checks the time on his Pulsar digital watch, and I remember thinking it was just the coolest thing I had ever seen. Eric leaned over and whispered, "They're really going to make those!" and the idea was astounding to me. It was absolutely the future.

After the digital watch obsession, including lusting after a Hewlett-Packard watch I saw in *Playboy* magazine (long story), I started moving on to chronographs, that sort of thing. But in my mind there was always a gap between what I aspired to and what I believed I could actually own. I just thought, "This is never going to happen."

I had completely forgotten about my James Bond Rolex fantasies until I started working on this book with Matt. Hearing all these guys tell their stories while I photographed their watches, it all just started coming back to me.

These days I wear a Rolex Submariner that my wife gave me as a birthday gift. I can have my watch without needing to cut it out of a magazine—but I still appreciate all the times I've been able to dig myself out of a hole with just a little imagination.

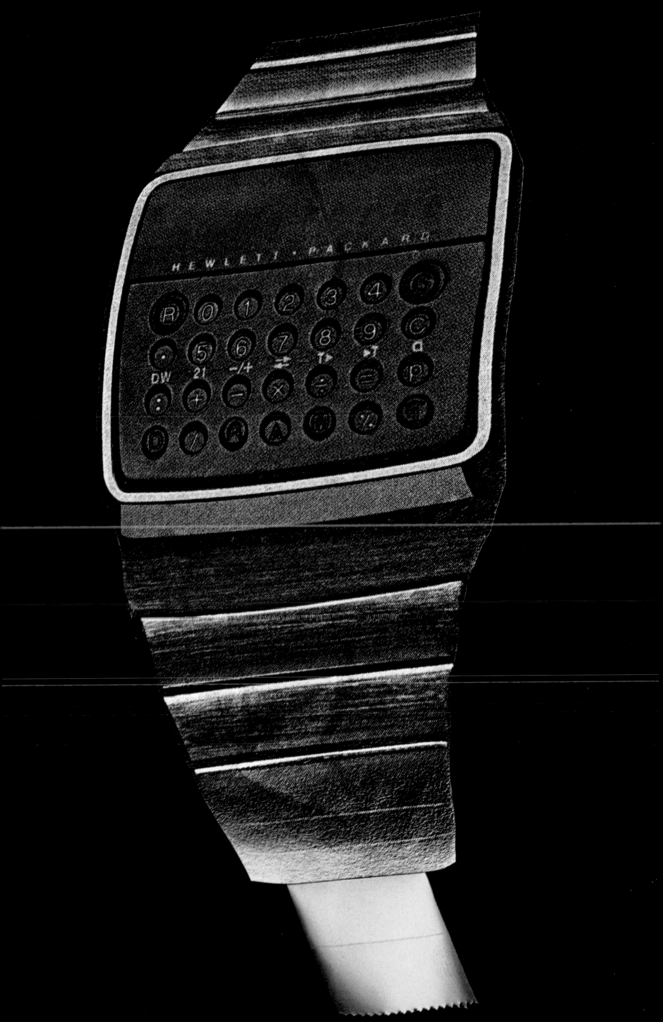

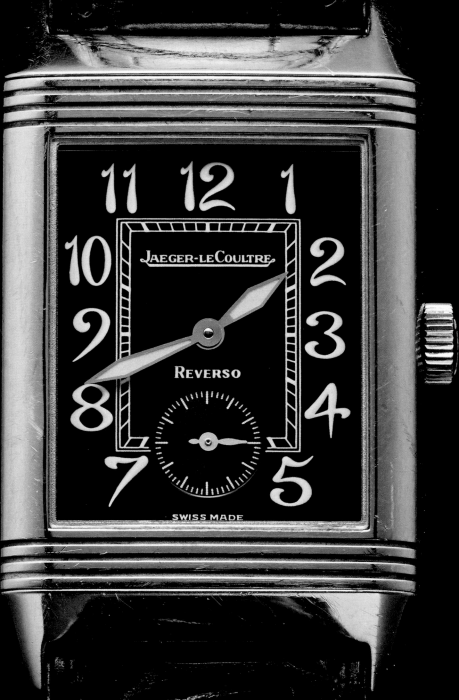

DAVID COGGINS

WRITER

JAEGER-LECOULTRE REVERSO

I'm not a watch obsessive. I don't know the intricate details; I'm not impressed by how much they cost or how rare they are. But I do respond to a certain type of watch. I want something that's well-made and designed with purpose—just like a suit, for that matter. And I like to wear a watch every day—I have one that I wear when it's light out, and one that I wear at night or on more formal occasions. The nice watches have always been gifts.

In that tradition, my Reverso was a gift from my parents. The brand was originally developed for polo players; I'm certainly no polo player, but I love the idea that you would wear this watch to the hotel in Buenos Aires, and then when you went to play polo, you'd just flip the watch case over to protect the crystal. And there's heft to it—you feel it when you flip it over and it clicks. There's a purpose to the way it moves.

I think you can tell a lot about a man from his watch, and I prefer one that errs on the side of discretion. Also, though I generally don't like monograms, I like that my initials are on it, but they're hidden—so it feels like a secret. And I like that it's from my parents, and that I use it. At first it seemed like an event when I wore it, so I was reluctant. Now I wear it more often, and it feels like something special in my everyday life.

Another thing I love about this watch is the beautiful Art Deco numerals, which are a bit whimsical—they remind me of an era in Europe that was less technical. The watch speaks to a certain type of dress—a coat and tie, not jeans or chinos. This isn't a watch I bring to Montana, but it's one that works very well in Paris and Italy, or for the opera in New York. I like those distinctions. I wear dark clothes, a lot of brown, and I like how the black face stands out against the brown. I'm sure that's breaking some rule, but I don't mind.

"I think you can tell a lot about a man from his watch, and I prefer one that errs on the side of discretion."

—DAVID COGGINS

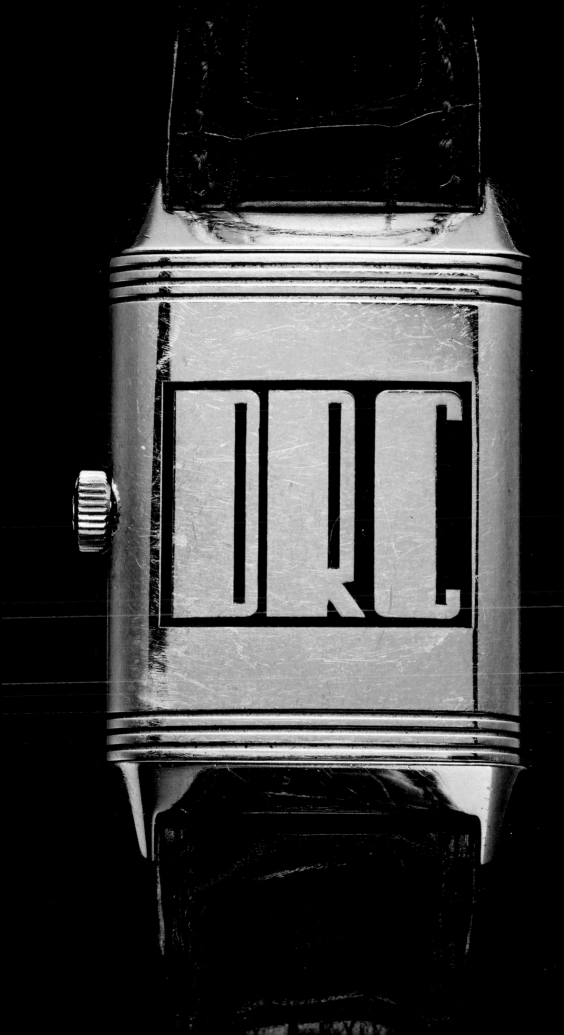

FROM THE
HERMÈS ARCHIVES

Unlike all of the other archives I visited, Hermès's are in Paris, not Switzerland. Hermès as a brand had its roots in the equestrian world, with its saddles and beautiful leather goods. When wristwatches became more popular than pocket watches, there was a need for a watch strap. Since Hermès made such stylish and well-crafted leather goods, it was only natural that watchmakers would pair up with them and make timepieces for them. Hermès wasn't a watch manufacturer, so the company had a type of freedom conducive to experimentation and whimsy that aren't often associated with Swiss timepieces—a reversible watch, for example, reminiscent of the Reverso that they were also producing, was integrated into a belt meant for golfers. As revealed in the company's archives, the designers at Hermès had an amazing way of looking at watches through a celebration of leathercraft, style, and fashion. In other words, very Hermès.

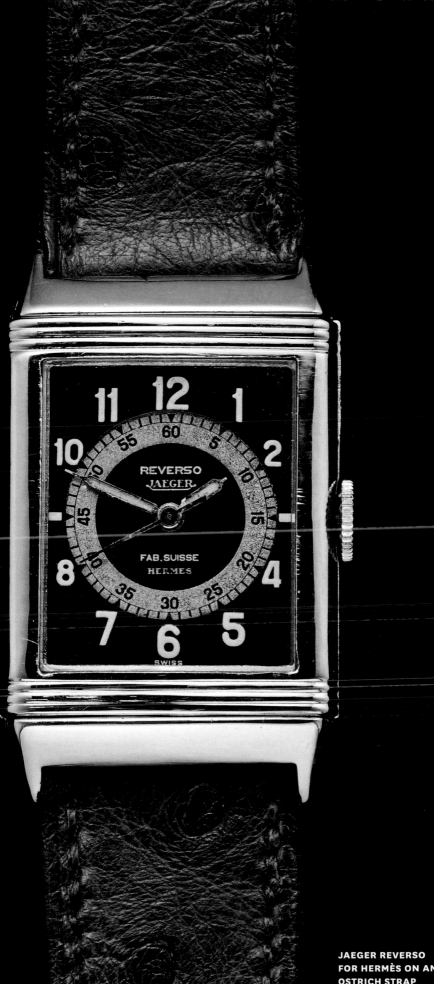

JAEGER REVERSO
FOR HERMÈS ON AN
OSTRICH STRAP

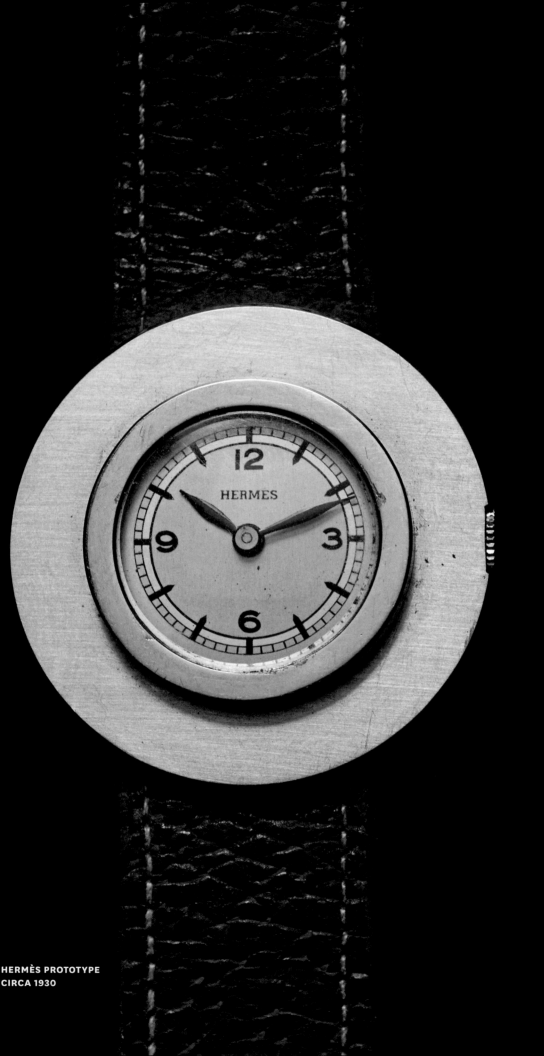

HERMÈS PROTOTYPE
CIRCA 1930

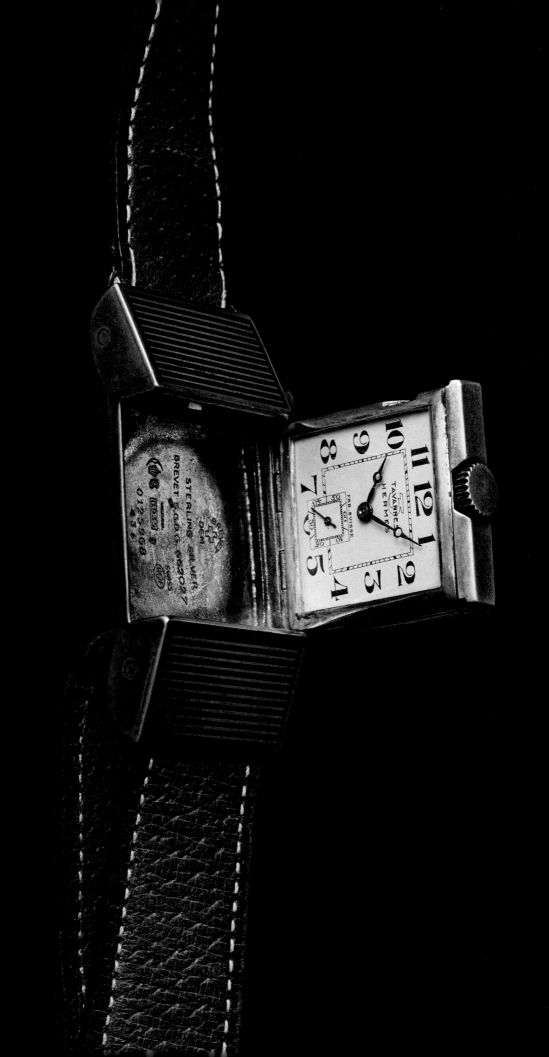

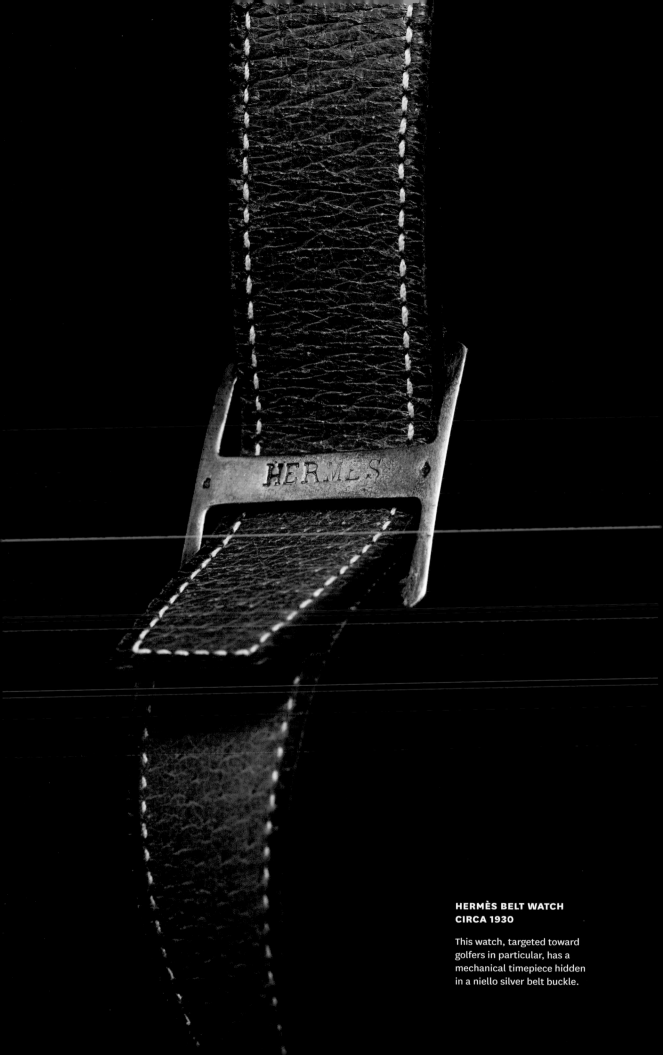

**HERMÈS BELT WATCH
CIRCA 1930**

This watch, targeted toward golfers in particular, has a mechanical timepiece hidden in a niello silver belt buckle.

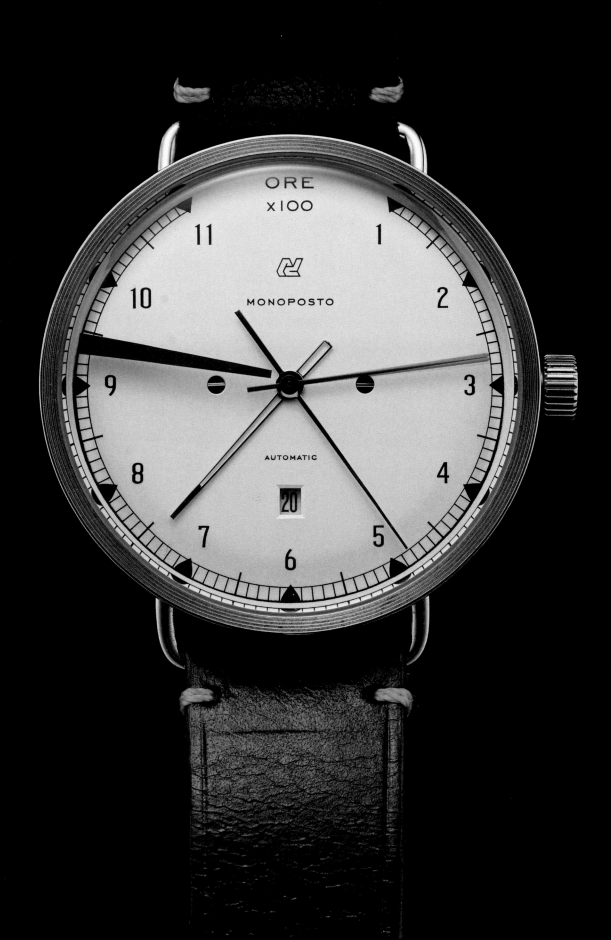

BRADLEY PRICE

FOUNDER & PRODUCT DESIGNER, AUTODROMO

AUTODROMO MONOPOSTO

For about ten years I was a product designer for all types of consumer electronics, appliances, furniture, and branding projects. But even before I was in the studio environment, from the very beginning of my career, I wanted to go out and do my own thing.

Since childhood, I've been totally obsessed with vintage cars. I didn't grow up in a watch family—I grew up in a car family. My dad had an Austin-Healey when we were little, then a Jaguar XK140, and a Jaguar E-Type that was around briefly, then a Jensen-Healey. I spent my whole childhood learning about vintage cars and the history of racing.

One day, I'm driving through the woods in my Alfa Romeo GTV6, an early-eighties sports car. I'm looking at the gauges, noticing the typefaces on them, and thinking, "You know, this would make such a cool watch—something inspired by the gauges."

I had never seen that, like what Bell & Ross does with aviation gauges, but for an automotive-inspired watch. I thought, "I could do that."

From the beginning, the idea was to do an Italian-themed brand, because I'm so passionate about Italian cars. The original collection was the quartz collection, using Ronda quartz movements. There were series called the Brescia, the Vallelunga, and the Veloce.

The quartz collection was great to get the company off the ground, to make a name for ourselves, but I kept hearing from customers that they loved the design sensibility and the ideas but really wanted something with an automatic movement. Quartz just doesn't have the same romance to it. I was still concerned about the risk of investment, however, so when I decided to up the ante with an all-new mechanical watch called the Monoposto, I made it a limited-edition run of just five hundred pieces.

The idea for the watch came from the gauges on fifties Grand Prix cars. These gauges were just enormous, the size of dessert plates, for visibility. But designwise, they were also minimal, and they often had a red line painted or taped on the glass. The mechanics would do that to tell the driver, "Shift here," so he didn't blow the engine.

I loved the ad hoc nature of painting that line right on the gauge, so I translated that by painting the line directly on the crystal, floating over the face instead of as a dial design. It's also a slightly oversized watch, at 43mm, as a nod to those huge gauges.

Monoposto is significant because it was the first watch that made a lot of people who might have dismissed the Autodromo brand look again and say, "This company is into making something special— not just something to sell." It became a bit of a cult hit and proved there was a market for us to make something more expensive, more lavishly produced, of higher quality, and with a certain integrity. It was an affirmation that we were on the right path, that we had an audience for what we were trying to do, and that we had a growing respect as a company.

I think Autodromo resonates with people because we're still a tiny company; basically, one guy designing stuff. But if you look back at even the well-known Swiss watch brands, they were much smaller companies back in the fifties and sixties—they didn't have the level of bureaucracy and layers of marketing people they have now; there wasn't a disconnect between people's emotional, intuitive, visceral ideas and the product. In a way, I'm creating more in line with how watches from those eras were produced, when manufacturers were saying, "These are the things I want to make."

The Autodromo legacy is still being written. We're a new company, obviously. But that's the point: we're a new company, doing new things that are changing all the time. I don't care about trying to create something that lasts for the ages; I'm trying to create something that excites people now, something that they want to buy and own. It's up to history to judge whether those things are good or collectible or valuable.

"I don't care about trying to create something that lasts for the ages; I'm trying to create something that excites people now, something that they want to buy and own."

—BRADLEY PRICE

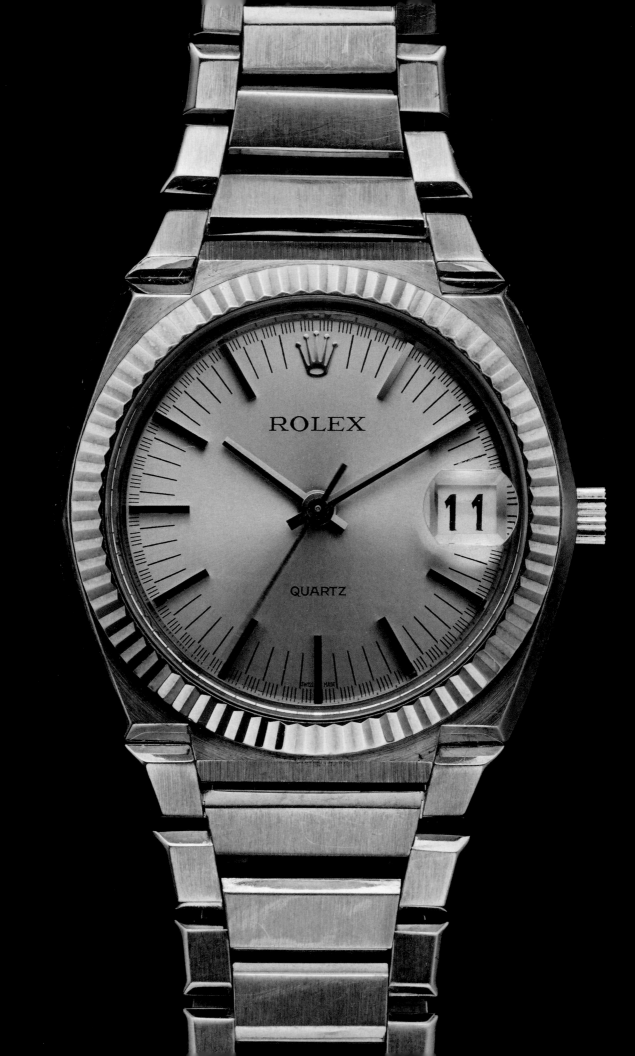

GOLD ROLEX QUARTZ REFERENCE 5100

This watch, also known as "Beta 21," was launched in 1970 as one of one thousand examples released by the watchmaker. It was not only Rolex's first quartz-powered watch, but the first of the brand's models to be fitted with a sapphire crystal and quickset date. While Rolex produced only a limited number of examples after that initial run, it's interesting to note that the entire thousand-unit first batch was sold out before the watch hit the market.

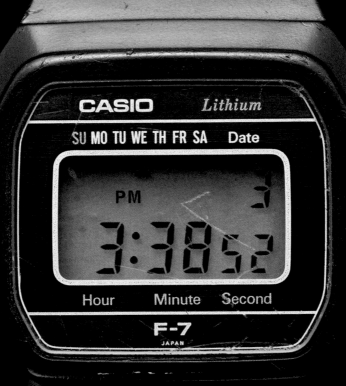

1980 CASIO F-7

ADAM CRANIOTES

WRITER & COFOUNDER, REDBAR GROUP

**1980 CASIO F-7 & 2012 IWC BIG PILOT'S WATCH
PERPETUAL CALENDAR TOP GUN REFERENCE 5029**

Growing up, I spent my summers with my grandparents in upstate New York. In the Oakdale Mall there was a store called Bradlees where my grandmother liked to shop. My grandfather must have noticed that every time we were there, I was just glued to the watch case. So one day—I was seven, going on eight—he comes up behind me and says, "Adam, which one do you want?"

My grandfather was a blue-collar guy through and through, not into watches. And the way I was raised, you got presents for Christmas and your birthday; in between, nothing, unless you saved a bunch of nuns from a burning bus or something. So you can imagine my surprise. I was like, "What's your game, Grandpa?" But the thing about my grandfather was, he supported passion—whether it was my writing, or sports I was into, or music that my sister and I listened to.

I didn't choose the calculator watch, *the* watch I wanted, because I knew that my grandparents didn't have a lot of money— and I wasn't supposed to be getting presents for no reason. So I settled on the Casio F-7, which had one button that activated a light—and I mean a little lightbulb, not some electroluminescent panel. It told time. No alarm, no calculator, no frills. But it was a watch, something I really wanted and had never had before.

When my mom came to pick me up at the end of the summer, I thought she was going to make me give the watch back. I remember sitting on my grandfather's lap across the breakfast table from her, trying to hide my wrist. But she never said anything, never acknowledged it. And years later, when the watch face was so scratched up you couldn't read the time, she sent it out to be serviced.

Fast-forward to this IWC. I was always an IWC fan, even becoming the moderator for the IWC forum on TimeZone. I wanted a pilot's watch, and that's something IWC is known for. This particular case style was brought back around 2003, and IWC entered into a partnership with the Top Gun flight school to license the name for the Big Pilot Top Gun line of watches. These particular watches have cases made of black ceramic, a material that IWC pioneered in the watch world, though they had never used it on a Big Pilot. And it has a double chronograph rattrapante and a perpetual calendar movement designed by Kurt Klaus, a living legend who defines IWC as a technical watchmaker. So when they announced this watch in 2012, it was like they had made *my* watch: Big Pilot, ceramic case, with a perpetual calendar. But the price was prohibitive; I'd never bought anything this expensive before and it was way out of my comfort zone. Even after selling a couple of other watches, I was still short.

My mom coughed up the rest, and you have to understand, she's not a woman given to ostentation or flash. She's so modest that when she was driving my dad's Mercedes to get her doctorate at Rutgers, she'd park the thing behind a dumpster. She's not someone who's going to say, "Oh, my son should have a $40,000 watch," but she, again, recognized this passion. And this is the watch that, in the collector business, in this hobby, I'm probably best known for.

So for me, these watches are a kind of alpha and omega; when I look at the Casio, I think of my grandfather, how he kicked off this hobby, how the switch was flipped and there was no turning back. And the IWC represents where I'm at now, and the fact that my mother, his daughter, also recognizes this passion and wants to encourage it.

Both of these watches always put a smile on my face when I wear them. And, as with any hobby, if you can't have that moment, you need to pick another hobby.

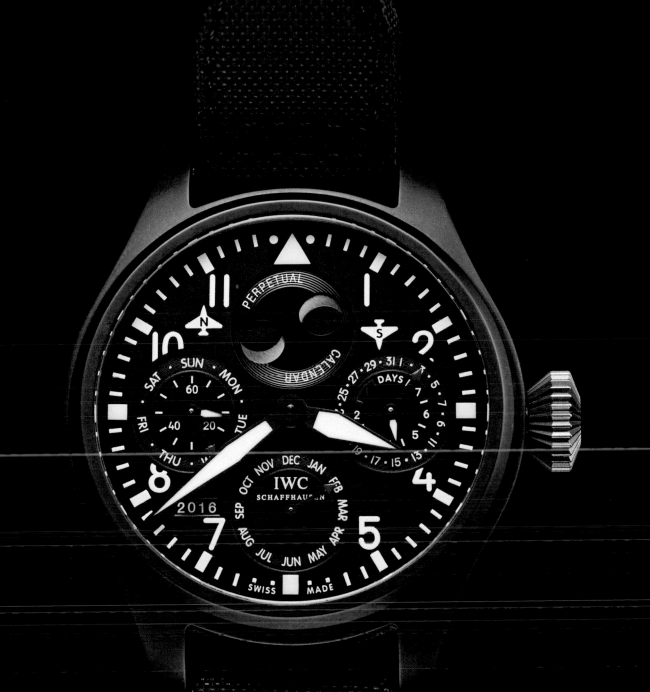

2012 IWC BIG PILOT'S WATCH
PERPETUAL CALENDAR TOP
GUN REFERENCE 5029

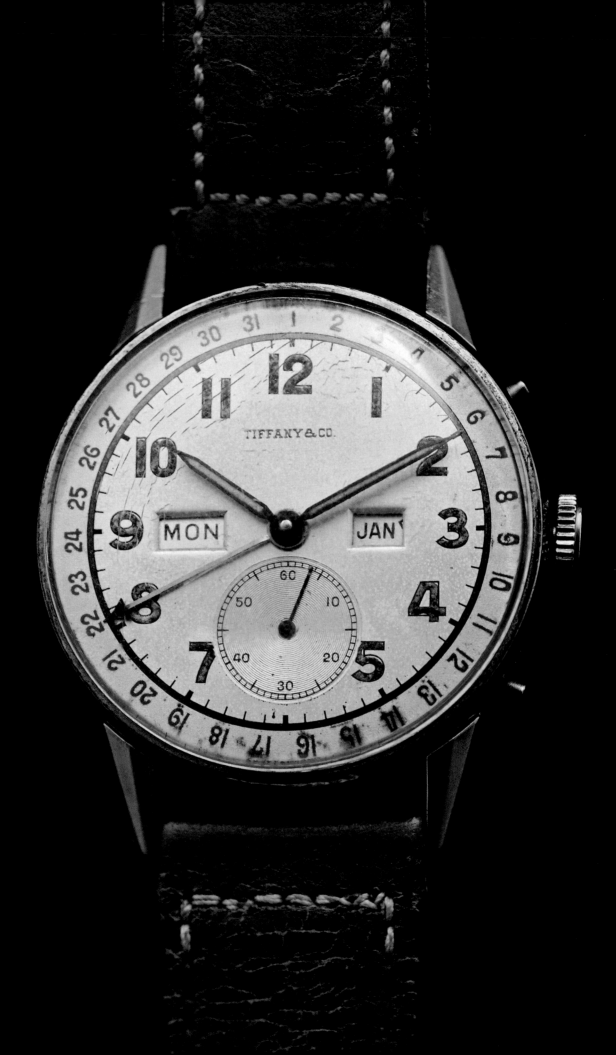

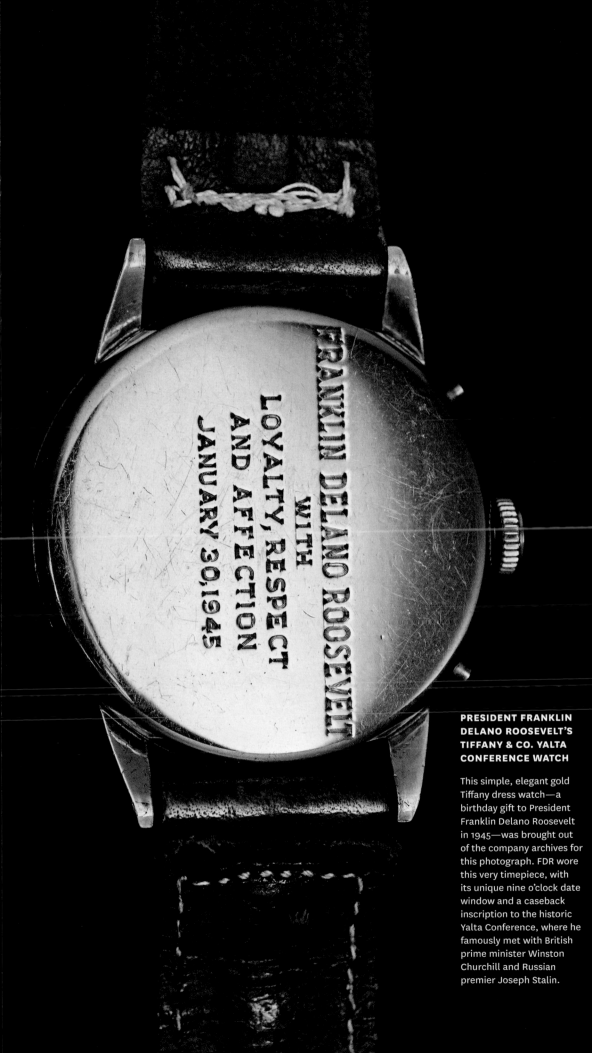

FRANKLIN DELANO ROOSEVELT
WITH
LOYALTY, RESPECT
AND AFFECTION
JANUARY 30, 1945

PRESIDENT FRANKLIN DELANO ROOSEVELT'S TIFFANY & CO. YALTA CONFERENCE WATCH

This simple, elegant gold Tiffany dress watch—a birthday gift to President Franklin Delano Roosevelt in 1945—was brought out of the company archives for this photograph. FDR wore this very timepiece, with its unique nine o'clock date window and a caseback inscription to the historic Yalta Conference, where he famously met with British prime minister Winston Churchill and Russian premier Joseph Stalin.

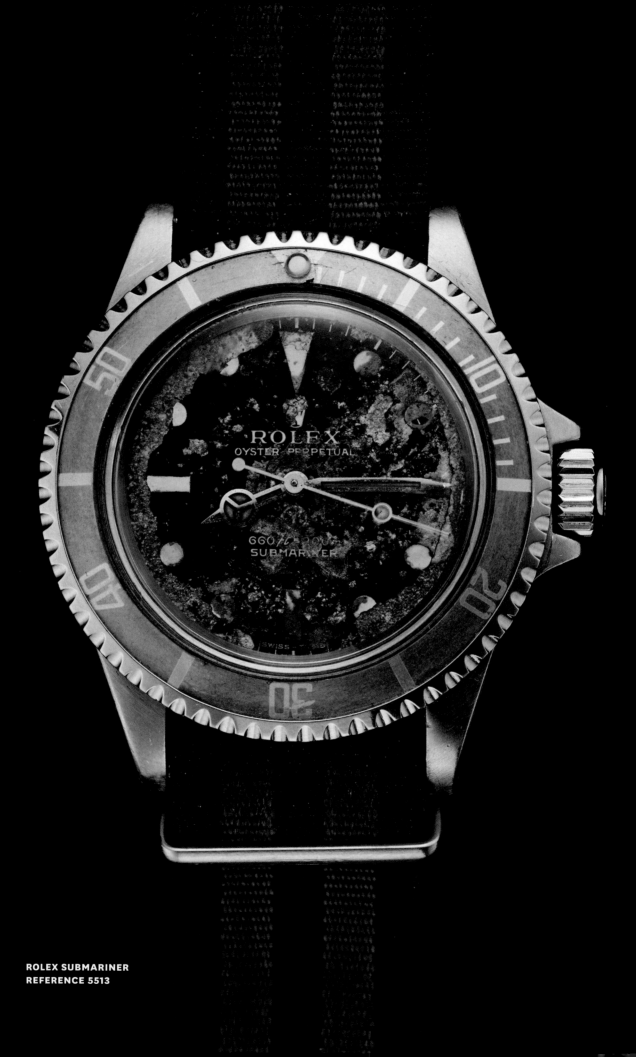

ROLEX SUBMARINER
REFERENCE 5513

GRAHAME FOWLER

FOUNDER, GRAHAME FOWLER ORIGINAL

**ROLEX SUBMARINER REFERENCE 5513,
ROLEX MILITARY SUBMARINER REFERENCE 5517 &
OMEGA SEAMASTER 300**

I first became interested in military watches as a child growing up in Africa. My dad was in the English Royal Corps of Signals, and he was based all over the Middle East and northern Africa. I was taken to school in a Land Rover, and all the men wore uniforms and had military watches and guns.

It was a dream upbringing for the subconscious, really. It's odd, the way a lot of what you see as a child or experience with your parents subliminally becomes part of your adult lifestyle. Like, I've only ever owned Land Rovers. And then, as I got into collecting and selling vintage clothes and cars and bikes and scooters, the watch thing just came naturally.

This is a Rolex Submariner reference 5513. It's from somewhere between 1972 and 1978. It was found on a beach in Dorset, where the English navy's Special Boat Service trained. I think it must have belonged to one of the SBS guys. Maybe it fell off his wrist from the rubber high-speed dinghy when they were coming into land, and it ended up under the sand for twenty-odd years. Some chap with a metal detector on the beach trolling for lost coins came across it and sold it to a local watch dealer. Then a friend of mine purchased it and took it to Rolex to have it repaired, and I eventually bought it from him.

A lot of people say it's wrecked. Actually, it's destroyed, but for me it's a work of art. It's like a piece of sculpture. The dial's been corroded and faded from years of being washed about and water getting in and degrading it. But instead of just putting in a sterile dial, I think it's really interesting to have it sealed in this moment of time. And it actually keeps fantastic time—you just can't tell what time it is.

"I became interested in military watches as a child. My dad was in the English Royal Corps of Signals, and all the men had military watches and guns."

—GRAHAME FOWLER

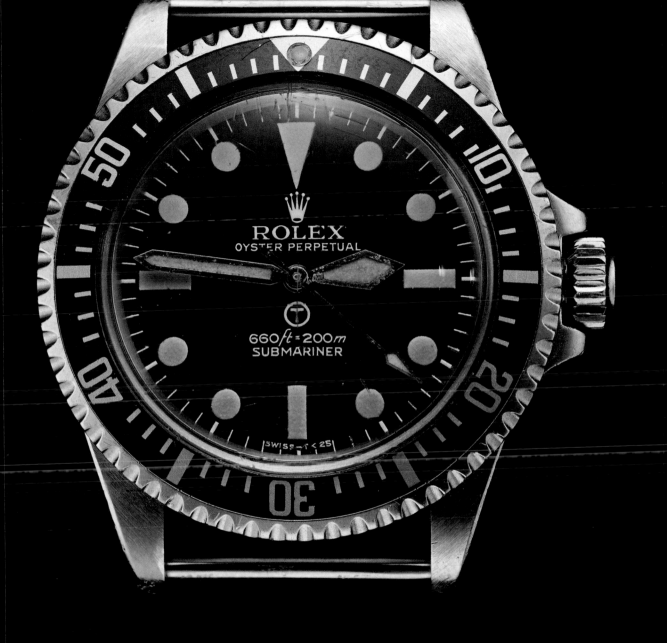

ROLEX MILITARY
SUBMARINER
REFERENCE 5517

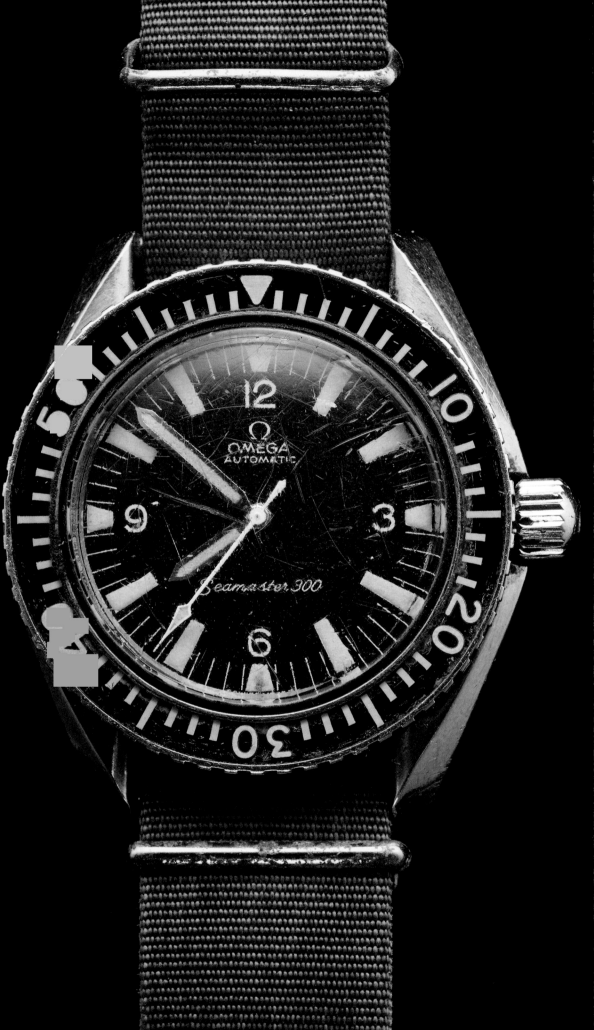

OMEGA SEAMASTER 300

An extremely rare British military-issued 1967
Omega SM300 for the Special Air Service (the
absence of a "T" on the dial denotes that it's
a very early example), this watch was used
on special operations in Northern Ireland by

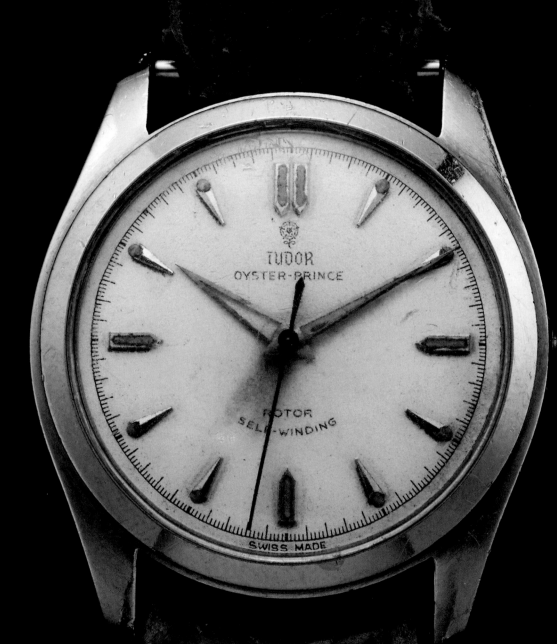

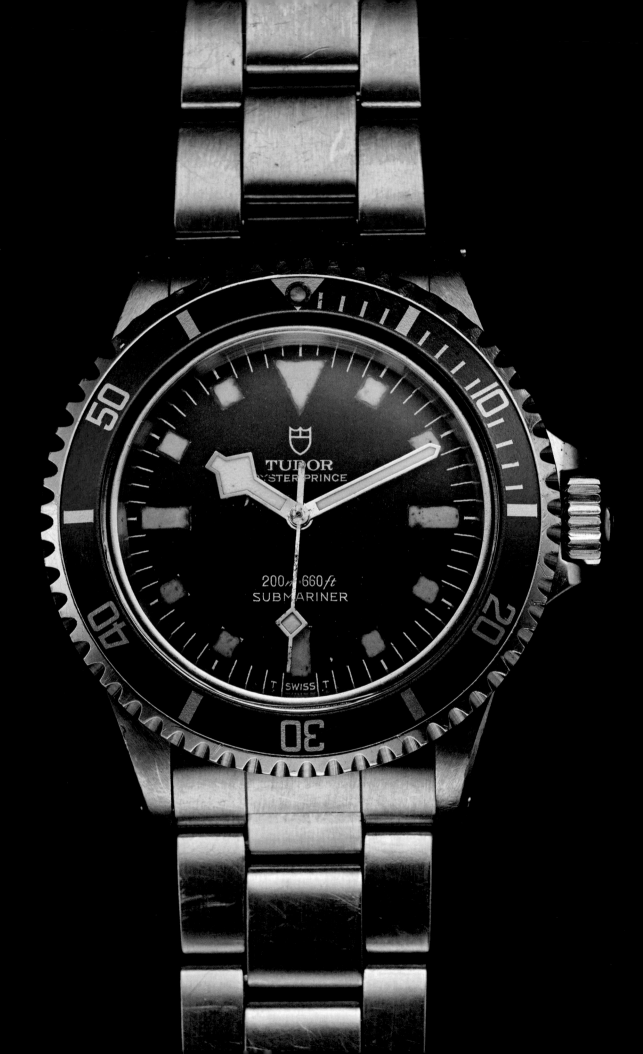

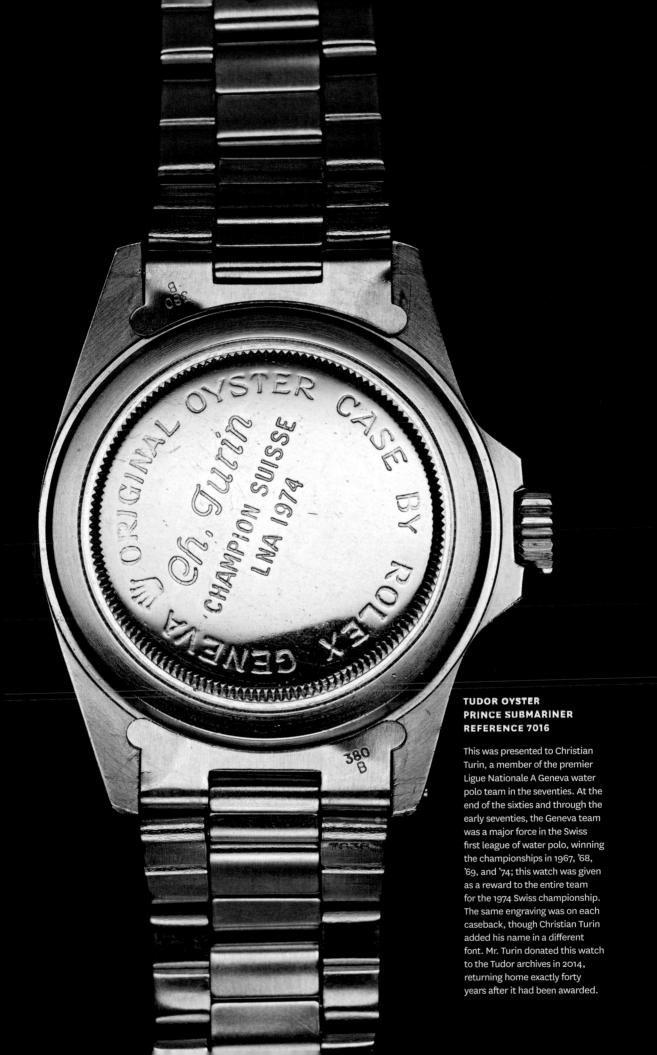

TUDOR OYSTER PRINCE SUBMARINER REFERENCE 7016

This was presented to Christian Turin, a member of the premier Ligue Nationale A Geneva water polo team in the seventies. At the end of the sixties and through the early seventies, the Geneva team was a major force in the Swiss first league of water polo, winning the championships in 1967, '68, '69, and '74; this watch was given as a reward to the entire team for the 1974 Swiss championship. The same engraving was on each caseback, though Christian Turin added his name in a different font. Mr. Turin donated this watch to the Tudor archives in 2014, returning home exactly forty years after it had been awarded.

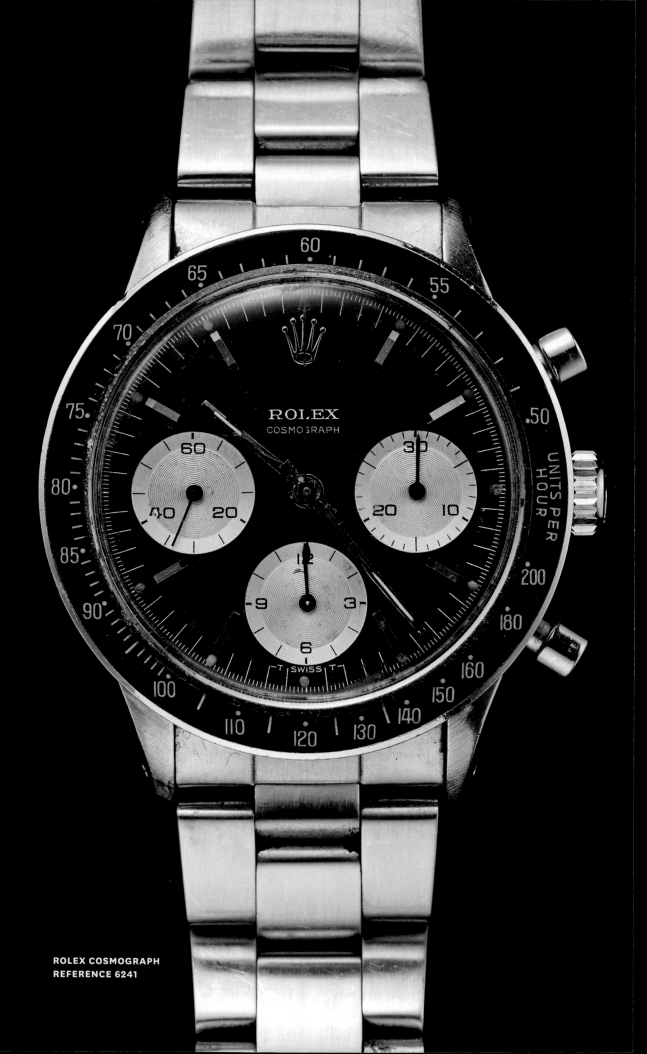

ROLEX COSMOGRAPH
REFERENCE 6241

HENRY LEUTWYLER

PHOTOGRAPHER

ROLEX COSMOGRAPH REFERENCE 6241 & ROLEX OYSTER BUBBLEBACK

I am an only child, and I was twenty-five when my father died from a heart attack at age fifty-seven. My mother loved him so much, and a few years after he passed, I knew that she couldn't stay in the house they'd shared, seeing ghosts of my father in every room. So we sold the house and moved her into an apartment. And we sold my bed, my furniture, lots of things. My father taught me early on to acquire things not based on monetary value, but because you love them. You live with them and enjoy them—and then you let them go. So I took a bit of the money and bought this Rolex Cosmograph watch secondhand to commemorate the time when I was a kid, when my father was alive.

It's a magnificent watch. I wasn't really a watch-head; I didn't buy it because I thought it would be worth something. I bought it because I liked it. It's a nice souvenir of happy days with both my parents in our house.

I also have the Rolex Bubbleback that belonged to my uncle, my mother's brother. I inherited it when he died. I'm Swiss-Italian—Italian on my mother's side—and I think of the Cosmograph as my Swiss side and the Bubbleback as my Italian side.

I don't gamble; I don't believe in stocks and bonds. I believe in work, bricks, earth—and I like watches and nice cars. Don't ever get attached to money, because you can't take it with you six feet under. It comes and goes. My father lost a lot of money once, and he made it back; I also lost a lot of money at one point—there were days I had to ask my assistant for twenty dollars because I was completely broke—and I made it back, too. Even if I were to lose it all again, I would never sell these watches, whether they're worth a dollar or a million dollars. I will eat less, get thin, work hard, start over.

"I would never sell these watches, whether they're worth a dollar or a million dollars. I will eat less, get thin, work hard, start over."

—HENRY LEUTWYLER

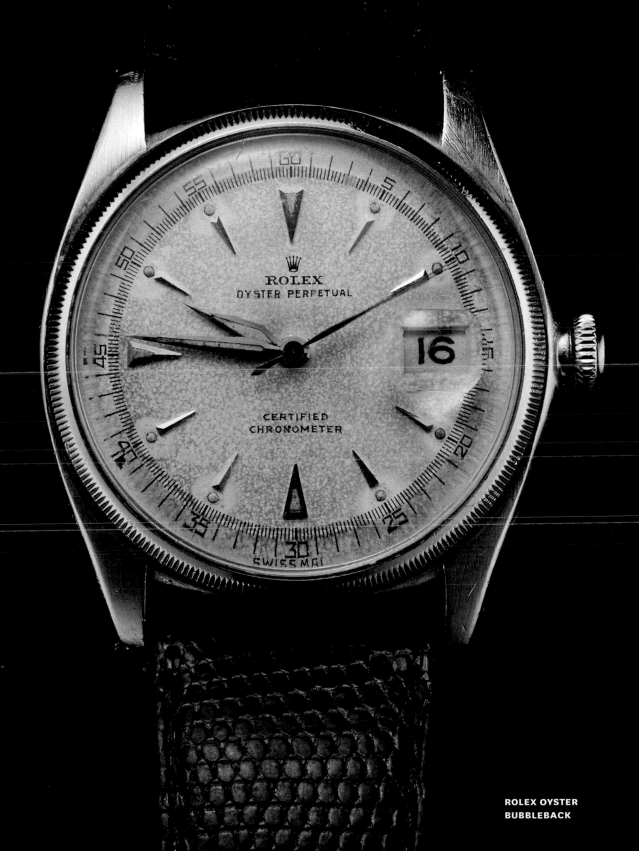

**ROLEX OYSTER
BUBBLEBACK**

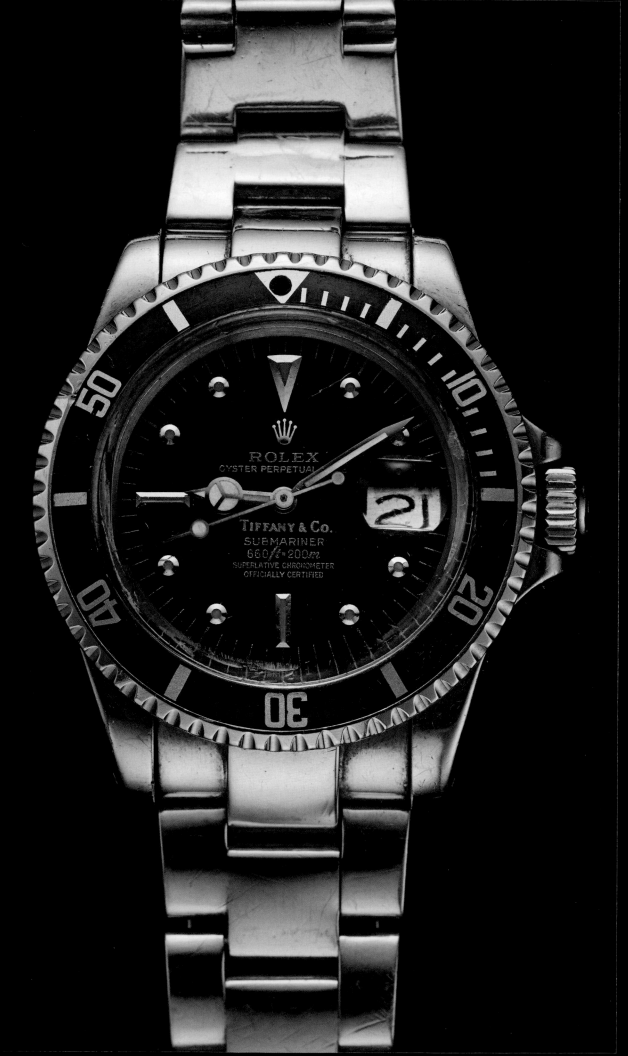

SYLVESTER STALLONE

ACTOR, DIRECTOR & SCREENWRITER

**TIFFANY & CO. GOLD ROLEX
SUBMARINER REFERENCE 1680/8**

This, by far, is the watch I'm most emotionally connected to. The first time I saw it, it was on the wrist of the rock star Gregg Allman, lead singer of the legendary Allman Brothers band. It was in 1976, we were on a plane, and Gregg was sleeping; I looked over and saw the most beautiful watch I had ever seen. As soon as we landed, I tracked one down, and it's been my pride and joy ever since. It was the first valuable thing I could afford to buy, and I still love it dearly. The strength, the simplicity, the masculine shape—it was perfect. It still is! It's like Rocky says to Adrian in *Rocky II*: "Do you like having a good time? Then you need a good watch!" This is one of the few things that connects me to the "good old days."

TUDOR OYSTER PRINCE SUBMARINER

When Jacek Kozubek, a watch dealer at
H.Q. Milton, in San Francisco, bought this
vintage Tudor, it came with a handwritten
note from the seller, unsolicited, telling
the story of the watch and the man who
had owned it: her father, who had been
a marine, a submariner, and mechanic
aboard the USS *Barbel*, stationed in Papa
Hotel—also known as Pearl Harbor. The
seller wrote, "Though it is hard for me to
part with my father's watch . . . my hope
is that someone will appreciate

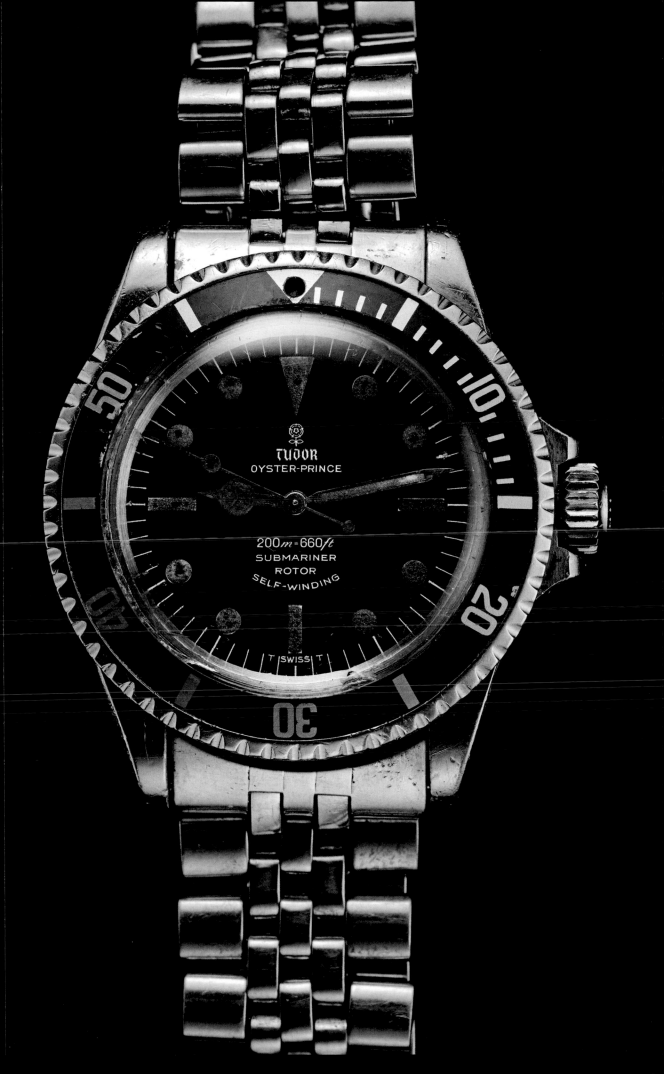

FROM THE
ZENITH ARCHIVES

I knew all the stories about how the pivot to quartz movements in the 1970s almost devastated the market for Swiss-made mechanical watches. Suddenly, mechanical movements weren't sexy or modern anymore, and the future belonged to quartz. The shift was so sudden, so violent and seemingly all-consuming, that in 1975, Zenith Radio Corporation, the American company that owned the Zenith Manufacture, whose El Primero had helped pioneer the wrist-worn chronograph in 1969, sent word to the factory in Le Locle, Switzerland: cease production of mechanical watches and destroy all the machines and tools for scrap. Head watchmaker Charles "Charly" Vermot protested directly; when his objections fell on deaf ears, he took another tack by carefully labeling and hiding away the cutting tools, cams, and heavy swage pressing equipment in a false wall behind a bookcase in an attic on the Zenith grounds.

Fast-forward a decade, and the quartz movement had failed to fully kill the fascination with craftsmanship and mechanical things. But while there was renewed interest in mechanical movements, the institutional knowledge of how to make them, and even the necessary materials, had all but disappeared in the lightning-fast purges of the quartz revolution. But thanks to Charly Vermot, who had saved the dies and the equipment, Zenith was able to return to producing beautiful mechanical movements. Not only did this help resurrect Zenith, but it also helped other brands; those same early movements found their way into early Rolex Daytona models as well. And they are beautiful movements—delicate and intricate and complex all at once. Being in the archive and seeing all the watches from both before that period—like the incredible pilot's watch that French aviator Louis Blériot wore when he became the first man to fly across the English Channel in 1909—and after was a wonderful reminder that if we let fads devalue that type of knowledge and skill and know-how, they can disappear before we realize how truly magical, and valuable, they are.

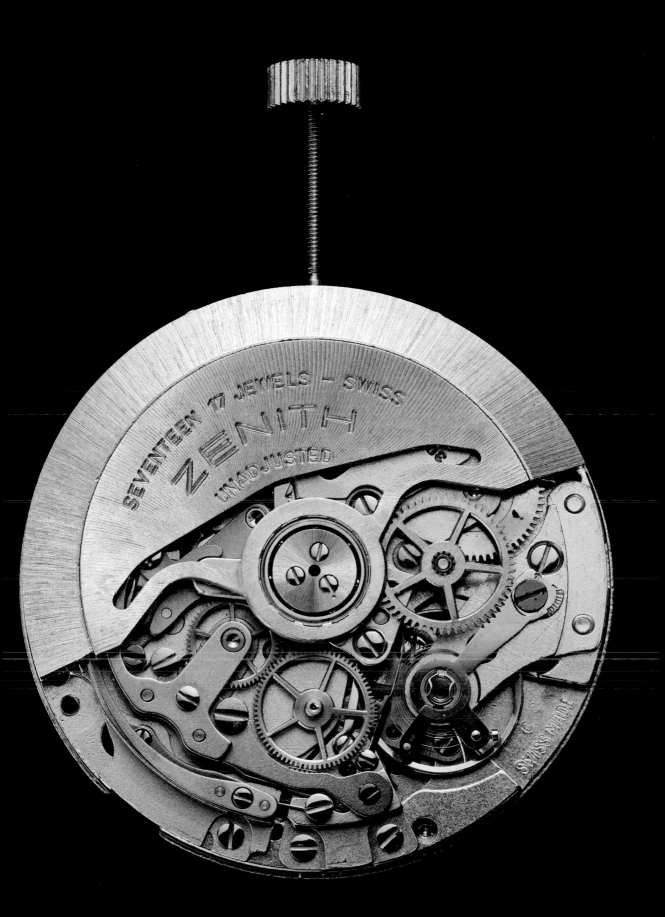

ZENITH EL PRIMERO
MECHANICAL CHRONOGRAPH
MOVEMENT

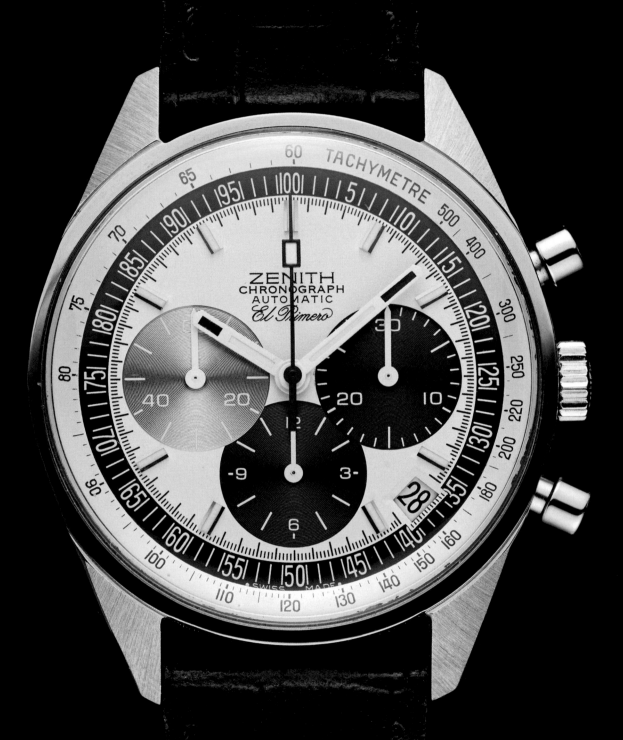

ZENITH EL PRIMERO
CHRONOGRAPH
CIRCA 1969

LOUIS BLÉRIOT'S ZENITH

This watch, created for
the famous French aviator,
eventually became the
Zenith Type 20.

RALPH LAUREN

CHAIRMAN & CCO, RALPH LAUREN CORPORATION

CARTIER TANK CINTRÉE

I went to an auction of Andy Warhol's watches, and I loved this great gold cuff on one piece. The watch it was attached to was nothing, but I purchased it and had the gold cuff sized to my wrist and put on this Cartier Tank Cintrée. It is one of my favorite watches. The combination is unique, and such a personal expression of a one-of-a-kind heirloom timepiece.

My earliest memory of a watch that made an impression on me was my father's. It was a big, round watch with a stopwatch function. My father was a real gentleman; he almost always wore a tie, and his watch was part of his look. In my teens and twenties, I began to be inspired by the debonair style of men like Fred Astaire and Cary Grant, and I noticed that their watches were an important detail of their look. I think a man and his watch have a special bond. It's probably his most signature personal piece—something he puts on every day. It's functional jewelry.

I believe in wearing different watches to match the mood of what you're wearing, where you're going. I see watches as I see clothes: part of a world we live in that changes from day to day. Everything I do and love is connected to a personal kind of emotion, and the watches I've collected over the years were never about their financial value but about the way they looked, the way they worked, how they made me feel. Certain watches can evoke an elegance and glamour of bygone eras—for businessmen, or a man dressed in black tie for an elegant evening—whereas others, like the utility timepieces made for pilots or soldiers, can evoke the experience of flying an aircraft, or steering a jeep across an open field. Creating my watch collections is about building something emotional for people who appreciate design and beauty.

I've always loved the beauty of things that were made to be used. That's why I love beautiful vintage vehicles—amazing racing machines like my Ferrari 250 GTO, rugged utility vehicles, or even a weathered truck. Each one was created for a specific purpose, and therein lies each one's peculiar beauty. I've always thought of my cars as moving art. I feel the same way about watches. It's moving art, worn on your wrist. I don't think there is anything like it in the world.

"I think a man and his watch have a special bond."

—RALPH LAUREN

ANDY WARHOL'S PATEK PHILIPPE REFERENCE 2503

There has been perhaps no artist as obsessed with the intersection of image and commodity as Andy Warhol. And while most of his personal style was steeped in standard Americana like Brooks Brothers oxford-cloth shirts and Levi's 501 jeans, his watch collection demonstrates an interesting and admirable taste for the iconic luxury horologists.

"I don't wear a Tank watch to tell the time," Warhol once said of his signature Cartier timepiece. "Actually I never even wind it. I wear a Tank because it is the watch to wear!" And while the godfather of pop art was probably best known for sporting Cartier's sleek dress watch, he also collected a range of Swiss timepieces, including a rose-gold Rolex Oyster Perpetual from the forties; Patek Philippe's first automatic wristwatch; and a rectangular Vacheron Constantin with playful twisted lugs. By some apocryphal accounts, Warhol owned as many as three hundred high-end watches, and kept his favorites grouped in the center of the canopy above his bed.

Among that number, he also owned this piece, the exquisite 1952 Patek Philippe reference 2503 with elegant teardrop lugs and leaf-shaped hands. The yellow-gold case sports a domed crystal, which adds extra depth to the applied numerals and markers. Like much of Warhol's wardrobe, it's a demure subversion of the classics; like his art, the playfulness pulls the excellent trick of heightening the impact without detracting from the significance.

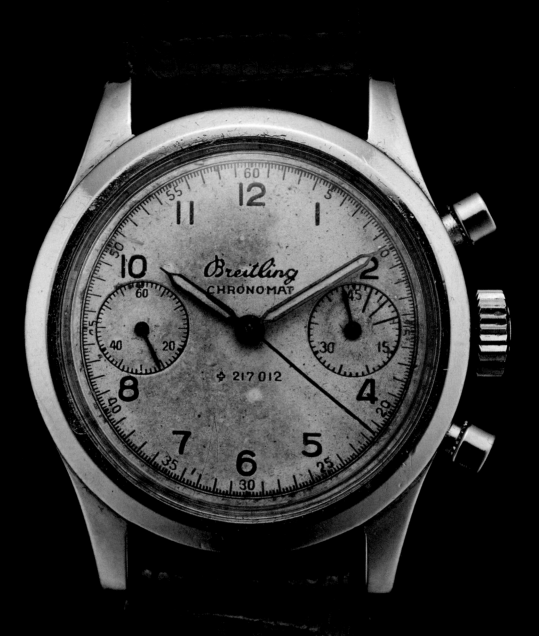

JOHN CRISCITIELLO

WATCH DEALER

BREITLING CHRONOMAT

I've been actively buying and selling watches since 1983. One year, I'm at a NAWCC—National Association of Watch and Clock Collectors—show. I have a booth there, and I'm walking around, and I see this interesting Breitling Chronomat from the late thirties or early forties. The particular case design is very rare: it has this special waterproofing system where the case isn't screwed on with a normal screw; it has four little machine screws under each lug; and when you turn the screws, it creates a water-sealing device. So I negotiate a little bit and purchase the watch.

I'm walking away from the guy's counter with every intention of reselling the watch when he says, "Hey, by the way, do you want to hear the story that comes with the watch?" I pause for a moment, turn around, walk back, and say, "Okay, what's the story?"

He proceeds to tell me that he had bought out all the repair watches from a jewelry store in Georgia, or maybe Alabama, one of those two. And this watch is the oldest repair in the shop—it was left in June 1941 by a GI who never came back for it. I started getting goose bumps, and when I left, I thought, "I can't sell something like this. I'm a caretaker." It was close to twenty years ago that I bought this watch, and it's still in my possession. I'll never sell it.

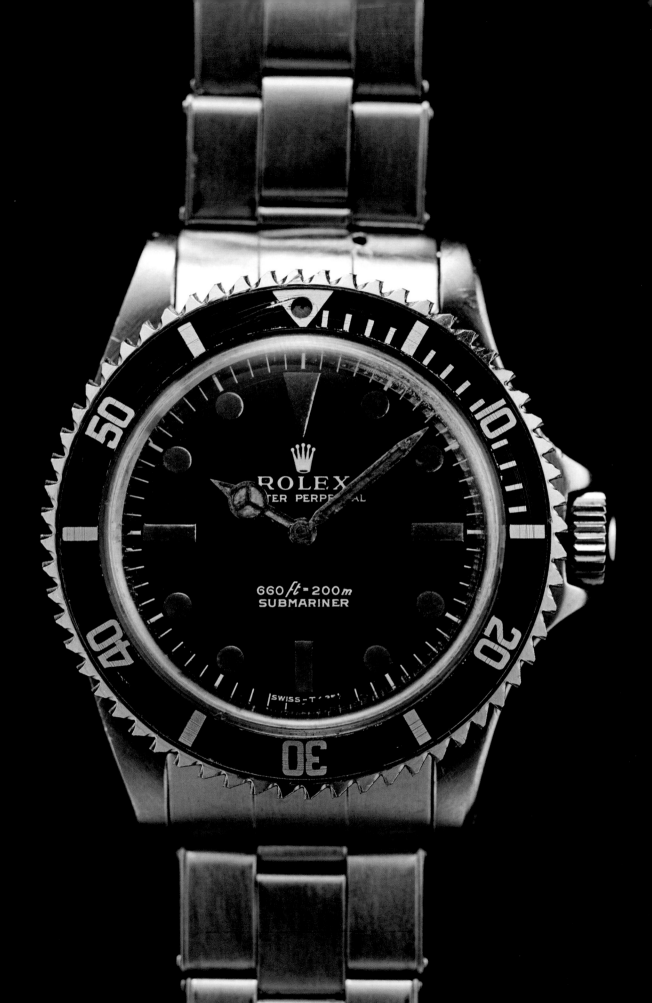

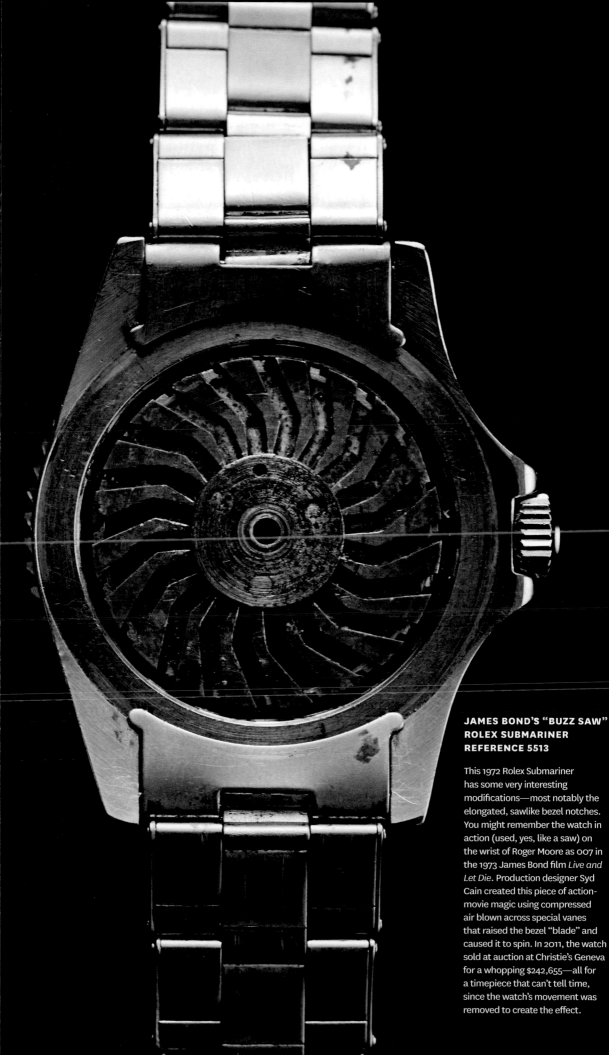

JAMES BOND'S "BUZZ SAW" ROLEX SUBMARINER REFERENCE 5513

This 1972 Rolex Submariner has some very interesting modifications—most notably the elongated, sawlike bezel notches. You might remember the watch in action (used, yes, like a saw) on the wrist of Roger Moore as 007 in the 1973 James Bond film *Live and Let Die*. Production designer Syd Cain created this piece of action-movie magic using compressed air blown across special vanes that raised the bezel "blade" and caused it to spin. In 2011, the watch sold at auction at Christie's Geneva for a whopping $242,655—all for a timepiece that can't tell time, since the watch's movement was removed to create the effect.

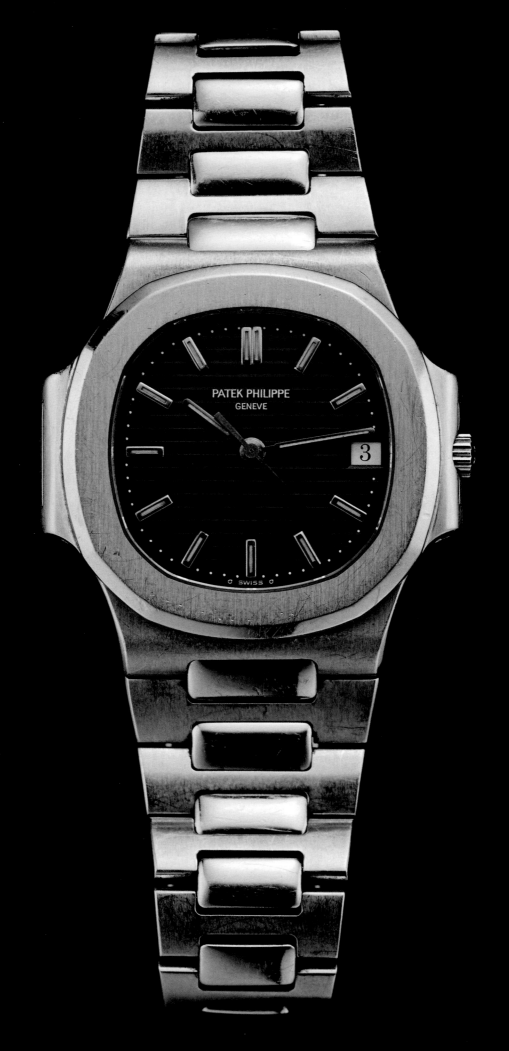

NATE BERKUS

INTERIOR DESIGNER & AUTHOR

**PATEK PHILIPPE NAUTILUS
REFERENCE 3800/A**

From a young age, I liked things of quality. Not necessarily expensive, but well-made. This applied to everything—my clothes, or decorating my room.

My parents always wore good watches, so I was around quality timepieces from a pretty early age. When I was twelve, my mother, who's also a designer, was working for a jeweler and decided she was going to get a watch for my stepfather. When I heard this, I piped up like a lunatic, begging for a steel Rolex. I even remember the model: the R100, the entry-level model right above the Air-King. So I got my first watch when I was twelve—I had to clean the house and wash the cars and babysit my sister to pay back my mother. I was obsessed with it.

There are two stories behind my Patek Philippe watch. My father owned the same model, and he wound up selling it, or losing it, before he passed away. I remembered that watch from when I was a kid—it was steel, and nobody knew much about it—so when I started making my own money and becoming more successful, that was one of the first watches I bought. I wanted one from my birth year, so I found and bought a used one (I always buy secondhand watches) from 1971.

I was wearing that watch when my partner, Fernando, and I went on vacation to Thailand, Sri Lanka, and Cambodia. That was 2004, when the tsunami hit. I survived; Fernando didn't. It wasn't until months later that I realized the watch had been on the trip, and that I didn't have it any longer. And I thought about it. I thought about whether or not I should replace it . . . and, for some reason, I was drawn to replacing it. I couldn't find one from 1971—I actually don't know the year that this one was made, but it's close. I found it from a dealer in Chicago. I remember the day I put it on. Looking down at it on my wrist, I realized it meant that that experience hadn't won. It hadn't taken me out.

I think we have two choices in life when somebody we love dearly dies. You either close the curtains and take the pills in the bedroom, or you throw the curtains open. You plant flowers. You light candles. And you try to move on. It's a very gradual process, and a really painful one, but there's a will to celebrate the person—and a will to celebrate yourself for having survived. I don't think of the tsunami every time I look down and see this watch. I think of the course of my life—the memories I have of my dad, the memories I have of Fernando. And also I think a lot about the future. The fact that it was one event, tragic and drastic, but one event in a long chain of events both happy and sad in my life.

"I don't think of the tsunami every time I look down and see this watch. I think of the course of my life—the memories I have of my dad, the memories I have of Fernando."

—NATE BERKUS

CONTRIBUTORS

MARIO ANDRETTI is considered by many to be the greatest race car driver in the history of the sport. His achievements are legendary. He is the only driver to have won the Daytona 500, the Indianapolis 500, and the Formula 1 World Driver's Championship. Andretti took the checkered flag 111 times during his fifty-year career. Since retiring from full-time competition in 1994, he stays active as a businessman and consultant and still does what he loves, driving the two-seater at many IndyCar races and giving rides to journalists, VIPs, and celebrities.

GEORGE BAMFORD is the founder of Bamford Watch Department, a personalization house that customizes luxury timepieces, leather accessories, men's grooming products, and cars. He lives in London.

NATE BERKUS established his award-winning interior design firm at the age of twenty-four. Since Berkus's first appearance on *The Oprah Winfrey Show* in 2002, he has become one of the world's most recognizable interior designers. His work has been featured in leading publications such as *Architectural Digest*; *House Beautiful*; *Vogue*; *InStyle*; *O, The Oprah Magazine*; *People*; and *Elle Décor*. Berkus is the author of two *New York Times* bestselling books, *Home Rules* and *The Things That Matter*, and he served as an executive producer of the Oscar-winning film *The Help*. His television shows include *The Nate Berkus Show, American Dream Builders*, and *Nate & Jeremiah By Design*. He lives in Los Angeles.

PAUL BOUTROS is a passionate watch collector and the Head of Americas and Senior Vice President for Phillips in association with Bacs & Russo, the watch department of the Phillips auction house. Boutros helped launch the department in 2014. He is a specialist in the authentication and valuation of collectible wristwatches and frequently shares tips on watch collecting on television and as the watch columnist for *Barron's PENTA*. He lives in New York City.

JACK CARLSON is an archaeologist. He holds a doctorate in Roman and Chinese archaeology from the University of Oxford and is the author of *Rowing Blazers*. He was also a member of the U.S. national rowing team and won a bronze medal at the 2015 World Rowing Championships. Carlson lives in New York City.

FRANK CASTRONOVO is the chef and co-owner of Frankies 570 Spuntino in downtown Manhattan and Frankies 457 Spuntino, Prime Meats, and Cafe Pedlar in Brooklyn. He is a costar of the Vice Media show *Being Frank*, a contributing editor to *Condé Nast Traveler*, and a coauthor of *The Frankies Spuntino Kitchen Companion & Cooking Manual*. He lives in New York City.

MARK CHO is a cofounder of the Armoury, a retailer of classic menswear in Hong Kong and New York, and a co-owner of Drake's, a British menswear brand with stores in London, New York, and Tokyo. He lives in New York City.

BENJAMIN CLYMER is a watch collector and the founder of Hodinkee, the world's most popular online watch magazine and retailer. Dubbed the "High Priest of Horology" by the *New York Times,* he has been credited with reviving interest in mechanical watches among members of the digital generation. He has consulted for several luxury brands, including Rolex, Vacheron Constantin, and Apple. He lives in New York City.

DAVID COGGINS is the author of *Men and Style*. His work has appeared in *Esquire, Condé Nast Traveler,* and the *Financial Times,* among other publications. He lives in New York City.

JOSH CONDON is a magazine writer and editor whose assignments have taken him from lifting weights with the country's top collegiate football prospects to barhopping with a crew of kilt-wearing Scotch whisky master distillers. He is also the author of *The Art of Flying*. He spends much of his work life flying around the world to drive fast cars. He lives in Brooklyn.

ADAM CRANIOTES is a watch enthusiast and writer. He is a cofounder of RedBar Group, the world's largest watch collectors' society, operating in over thirty cities across four continents. His horological obsession came from his grandfather, who bought him his first watch when he was seven years old. He lives in New York City.

JOHN CRISCITIELLO founded Alltiques in 1983. It has since become one of the most exclusive vintage watch dealerships in the world. He lives in New York City.

DIMITRI DIMITROV is the legendary maître d' of the Tower Bar at the Sunset Tower Hotel in Los Angeles. Stars like Jennifer Aniston have credited him with creating a "haven" for guests by offering a loyal and unmatched level of service and discretion. Dimitrov, originally from Macedonia, has decades-long experience in the service industry, and he is a key orchestrator of the classic elegance at the Tower Bar, which he runs "with an iron fist in a velvet glove." He lives in Los Angeles.

GRAHAME FOWLER was born in Plymouth, England, and grew up in Kenya. He developed an interest in watches at a young age, when he would admire the watches that belonged to his father, a military man, and all of his father's army friends. In 1999, after several moves around the world, Fowler relocated to New York City, where he opened Grahame Fowler Original, a menswear boutique.

MICHAEL FRIEDMAN is a horological expert and the historian for Audemars Piguet. Previously he was a curator at the National Watch and Clock Museum in Columbia, Pennsylvania, as well as Vice President and Department Head of Watches at Christie's. He lives in New York City, where he is also active in film production and songwriting as much as time permits.

GEOFFREY HESS is the CEO of Analog/Shift LLC, an online vintage watch retailer, and previously was the president and CEO of Ivanka Trump Fine Jewelry. He is a founding member and partner of Giuliani Partners LLC, the management consulting firm formed by former New York City mayor Rudolph Giuliani, and was senior advisor to the mayor during the Giuliani administration. He has been a watch collector for most of his life. Hess lives in New York City.

KIKUO IBE is the chief engineer at Casio and the inventor of the Casio G-Shock. He also developed Casio's Oceanus watch line, the company's first ever radio-controlled and solar-powered watches with a sophisticated aesthetic. He lives in Niigata Prefecture, Japan.

ERIC KU is an expert watch dealer and scholar, specializing in vintage Rolex timepieces. His love affair with watches started when he was very young and would peek into his father's watch drawer to admire his treasures. Ku's Vintage Rolex Forum is the most visited website dedicated to the study of vintage Rolex watches. He also owns 10 Past Ten, a highly praised virtual vintage watch dealership. He lives in San Francisco.

JAMES LAMDIN is the founder of Analog/Shift, a New York City–based vintage watch retailer. He is a contributor to a number of leading print and online publications in the automotive and horological fields. He lives in New York City.

RALPH LAUREN is a fashion designer and cultural icon whose name is synonymous with American style, timeless design, and impeccable quality. He has built his fashion empire, Ralph Lauren Corporation, into one of the most successful companies in the world. His style of luxury is recognized and coveted by men and women everywhere. He lives in New York City.

HENRY LEUTWYLER is an editorial photographer renowned for his celebrity portraits. In 1985, he moved from his native Switzerland to Paris, where he launched his career; a decade later, he relocated to New York. He is the author of *Neverland Lost*, *Ballet*, and *Document*, and has held solo exhibitions in Los Angeles, Madrid, Moscow, New York, Paris, Tokyo, and Zurich, among other cities. He lives in New York City with his wife and their two children.

STEPHEN LEWIS is the photographer for *A Man and His Watch*. Lewis grew up in Washington, D.C., and studied photography at Syracuse University. In 1985, he relocated to New York City, where he did some framing and gallery installations, and then worked as a photographer's assistant for four years before striking out on his own in 1990. His editorials have been featured in *Lui*, *T*, *Condé Nast Traveler*, *Vogue*, *W*, and *Bon Appétit*, and he has photographed advertising campaigns for Bulgari, Hermès, Salvatore Ferragamo, David Yurman, and Ralph Lauren, among many others. He lives in Brooklyn with his wife, their two sons, and a dachshund.

ATOM MOORE is a watch photographer and the art director at Analog/Shift, an online vintage watch retailer. He lives in New York City.

NAS is a Grammy-nominated musician and an entrepreneur. He has released twelve studio albums, eight of which went platinum and multiplatinum, and has sold millions of records worldwide. He lives in Los Angeles.

"So much to write and say / Yo, I don't know where to start / So I'll begin with the basics and flow from the heart." —Nas, "Loco-Motive"

BRE PETTIS is a cofounder of MakerBot, Thingiverse, and NYC Resistor. A watch fanatic, in 2016 he launched Bre & Co., a manufacturer of watches, pens, pocketknives, jewelry, and ceramics. He lives in New York City.

HAMILTON POWELL is the founder and CEO of Crown & Caliber, an online marketplace for buyers and sellers of certified pre-owned watches. Prior to founding Crown & Caliber, he was the managing partner of Powell Growth Capital, a private equity firm. He lives in Atlanta with his wife and their three daughters.

BRADLEY PRICE is a product designer and certifiable car nut. He has worked with clients such as PepsiCo, SC Johnson, Hearst, Panasonic, and LG, among others. In 2011, he launched Autodromo, a car-inspired luxury brand of men's accessories, which melds his lifelong passion for vintage cars with his wealth of experience in product design. He lives in Brooklyn and races a 1959 Alfa Romeo Giulietta Veloce Spider.

JAMES H. RAGAN is a physicist, retired NASA aerospace engineer, and space pioneer. He was responsible for the testing and preparation of the astronauts' flight hardware during the Apollo missions and played a key role in the testing of Omega Speedmasters for all NASA manned missions. Since retiring from NASA, he has worked as a consultant for Omega and other companies. He has also coached soccer and was a FIFA- and UIL-certified soccer referee. He lives in Spring, Texas.

ERIC RIPERT is the chef and co-owner of New York's Michelin-starred Le Bernardin, which currently ranks 17th on the World's 50 Best Restaurants list. It was also Zagat's top restaurant in New York City in 2017. In 2014, Ripert opened Aldo Sohm Wine Bar and Le Bernardin Privé, both of which are steps away from Le Bernardin. He was the host of his own Emmy Award–winning TV series, *Avec Eric*, and is the author of a memoir, *32 Yolks*, and five cookbooks: *Avec Eric*, *On the Line*, *A Return to Cooking*, *Le Bernardin Cookbook*, and, most recently, *My Best: Eric Ripert*. Ripert is a Chevalier of the French Legion of Honor. He lives in New York City.

TOM SACHS is a sculptor whose work is in the collections of the Museum of Modern Art, the Metropolitan Museum of Art, and the Solomon R. Guggenheim Museum in New York City; the J. Paul Getty Museum in Los Angeles; and the Centre Georges Pompidou in Paris, among many others. He has held solo exhibitions at prominent art spaces worldwide. He lives in New York City.

AARON SIGMOND is an award-winning media executive, a writer, and the author of six books, including *Drive Time: Watches Inspired by Automobiles, Motorcycles, and Racing*, who has written for the *Hollywood Reporter*, Time, Inc., Thrillist Media Group, Robb Report Media, *Playboy*, *Private Air*, *Elite Traveler*, and *American Photo*. He is currently a columnist for *Jing Daily*. Sigmond divides his time between New York City and Charleston.

ALESSANDRO SQUARZI is a fashion entrepreneur, a talent scout, and an international style icon with one of the largest vintage watch collections in Italy. He lives in Milan.

SYLVESTER STALLONE is a three-time Oscar-nominated actor, filmmaker, and screenwriter. He is best known for his role as Rocky Balboa in *Rocky* and its several sequels. He lives in Beverly Hills.

ENG TAY is an artist who has exhibited throughout the United States and Asia. Tay is a passionate collector of vintage and contemporary watches. He lives in New York City.

HOLGER THOSS was born in Germany and now lives with his wife and two boys in Brooklyn, where he explores the mysteries of family life and photography. He and his family share a passion for the outdoors and enjoy taking long road trips.

GABRIEL VACHETTE is the founder of *Les Rhabilleurs*, an online lifestyle magazine dedicated to watchmaking and integrating watches into everyday life. He lives in Paris.

MAX WASTLER is a brand strategist, writer, photographer, and clothing designer. His day hasn't started until he's heard the rip of his Velcro watch strap. He lives in Los Angeles.

KENTA WATANABE is an indigo farmer and dyer. He cofounded Buaisou in 2012, in Tokushima, Japan, where he lives. The company is renowned for its indigo leaf farming, and for its tradition of composting the indigo leaves into sukumo.

ACKNOWLEDGMENTS

I would like to thank Gabriela Anastasio, Russell Kelly, and Sven Olsen at Tudor; the Beyer Zurich Clock and Watch Museum; Sandy Blanc at Hermès; Dana Brown; Mary Randolph Carter at Ralph Lauren; Christophe Chevalier at Tudor; Fabiana Chiacchio at Zenith; Derek Conrad at Tiffany & Co.; Hugues de Pins at Cartier; Liana Engel at Cartier; Catherine Eberlé-Devaux at TAG Heuer; Stephanie Fosnaugh for her retouching talents; Brandon Frazin at Christie's; Pilar Guzmán; Jeff Klein; Jacek Kozubek; Pascale Lepeu at Cartier; Paul Lerner; Becky Lewis; Material Good; Aldo Magada; Mounia Mechbal and Carla Stamp Uzel at Rolex; Chris Mitchell; Clea Newman; Dewey Nicks; Philippe Peverelli; Petros Protopapas at Omega; Stephen Pulvirent; Kiyo Taga-Witkin at Cartier; Yukiko Toyoshima at Longines; Inez van Lamsweerde and Vinoodh Matadin; Eric Wind at Christie's; my mom, Carmie; and my daughter, Clara. Thanks also to Josh Condon for all his help, enthusiasm, and hard work with the words in this book.

Thank you to the team at Artisan Books. Theresa Collier, Renata Di Biase, Mura Dominko, Michelle Ishay-Cohen, Sibylle Kazeroid, Allison McGeehon, Nancy Murray, and of course my thoughtful, enthusiastic, and ever accommodating publisher, Lia Ronnen, and editor, Shoshana Gutmajer.

Like many things in my life, this book would not have been possible without the support, encouragement, care, and patience of my wife and best friend, Yolanda Edwards.

INDEX

MATT HRANEK is the author of of *The Negroni*, *A Man & His Watch*, and *A Man & His Car*, as well as a photographer, director, and the founder/editor of the men's lifestyle magazine *WM Brown*. He and his family divide their time between Brooklyn and the Wm Brown farm in upstate New York, though he can also be spotted quite often in old-school bars around Europe, Negroni in hand. Find him on Instagram at @wmbrownproject.